Basic Drawing

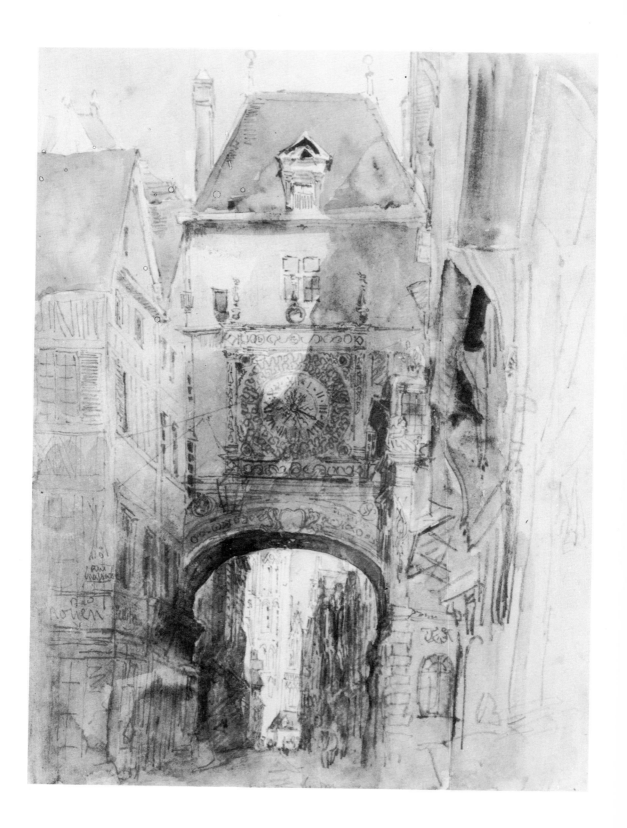

Basic Drawing

ROBIN CAPON

B T Batsford Ltd London

Drawing is the true test of art
Jean–Auguste–Dominique Ingres (1780–1867)

© Robin Capon 1984
First published 1984

All rights reserved. No part of this publication
may be reproduced, in any form or by any means,
without permission from the Publisher

ISBN 0 7134 1866 4

Typeset by Tek-Art Ltd West Wickham Kent
and printed in Great Britain by
Butler & Tanner Ltd
Frome, Somerset
for the publishers
B T Batsford Ltd
4 Fitzhardinge Street
London W1H 0AH

1 Frontispiece *Tour d'Horloge, Rouen* by David
Cox. Pencil and wash, 34 cm × 25.5 cm
Tate Gallery, London

Contents

Acknowledgment

I wish to thank the Trustees of the following Galleries and Museums for providing photographs and allowing reproduction of drawings in their collections: the British Museum; the Victoria and Albert Museum; the Tate Gallery; the National Portrait Gallery; the Ashmolean Museum, Oxford; the National Gallery of Art, Washington DC; The Solomon R Guggenheim Museum, New York; the Wadsworth Atheneum, Hartford, Connecticut; the Isabella Stewart Gardner Museum, Massachusetts; the collection of Mme Ginette Cardin-Signac; the Stedelijk Museum, Amsterdam; and Teylers Museum, Haalem. I also thank The Henry Moore Foundation for *figure 6,* John Lansdowne for *figure 36,* Davis and Long Company, New York for *figure 46* and Mr J. Clinch for *figure 76.*

I am grateful to Winsor and Newton Limited for assisting with information on materials and supplying a number of illustrations in this respect. I also thank my wife, Patricia, for typing the manuscript, and my editor, Thelma M Nye, for her help and advice in the preparation of this book.

Maidstone 1984 RC

Except where otherwise stated, all the illustrations are by the author.

Introduction

Since earliest times drawing has been a vital form of communication. Through drawing, man has been able to express his ideas about things and events, whether with emotional force or with objective fact. Drawing is a basic and natural form of self-expression: we all have an innate response to it.

From birth we are striving to communicate and express ourselves. The first cries of a baby are to the mother and may be purely an expression of hunger or discomfort. Later, as the child grows and gains strength and mobility he develops a curiosity for things around him. An early sensation is that of touch, of feeling things and becoming aware of different surfaces and textures. Touch is the first step towards grip, which in turn is a step towards co-ordination. The ability to grip something leads to the discovery that some objects produce a mark if scraped across a surface – the child makes his first drawing. Although such drawings may be made out of the sheer joy and manipulative experience of pressing crayon against paper, and are meaningless in the sense that they are not passing on a significant message, they are an important step in the child's development. In drawing, physical and mental experiences are linked. As the child grows, drawings will often state clearly and immediately what a child thinks or feels about something, an act of communication which he may find easier and more successful than verbal expression. These drawings will not be realistic and will not be influenced by rules and conventions. A child will emphasise what is important to him and the confident act of drawing becomes a personal language which is often charged with details and meaning not immediately obvious to the casual observer.

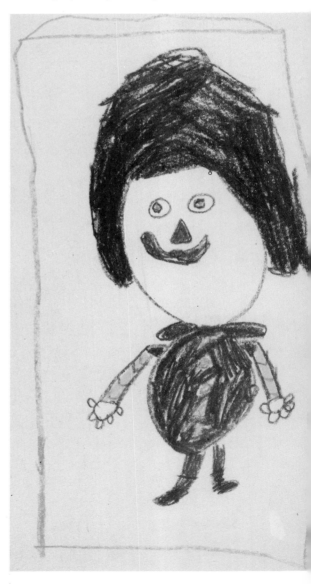

2 *Sentry* by a six-year-old girl. Wax crayons

Look at *The Sentry* by a six-year-old girl, illustrated in *figure 2*. Here the emphasis is placed on the head and face as the area of main interest. Possibly the small body is dictated by the available space, although a considerable amount of work has been put into the detailing of arms, legs, hands, fingers and so on. The drawing shows a feeling for the subject rather than a cold factual appraisal.

Unfortunately the eager and uninhibited **approach** is lost as children grow and witness more forceful influences and experiences. Older children and adults loose faith in their own efforts for a variety of reasons. They begin to question what they are doing and become self-critical. Such deliberation can be a valuable aspect of the drawing process providing it does not dominate. The 'perfect' graphic images produced from computers and found in advertising and film can also play a part in undermining confidence as can comparison with the work of the great masters. However, these influences can be just as much inspirational as dejecting. As instrumental in breeding uncertainty and disillusionment is a lack of knowledge of the vast range of materials, techniques and approaches possible to create a drawing.

A drawing may be made for many reasons. Like *figure 3* it may be based on pure observation, aiming to meet the challenge offered by shapes, forms and lighting. There has always been a place in art for accurate representational drawings of this type. In addition, they are as good for training the eye and making judgements on what we see as they are for perfecting techniques. Similarly, in *figure 4*, the drawing is made to impart information. Sometimes the information given is achieved at the expense of selection and emphasis. Contrastingly, a drawing can be subjective and emotional, expressing powerfully a feeling or opinion about something. A drawing can be just as much influenced by the medium used as by

3 *Still life group*, pencil and charcoal

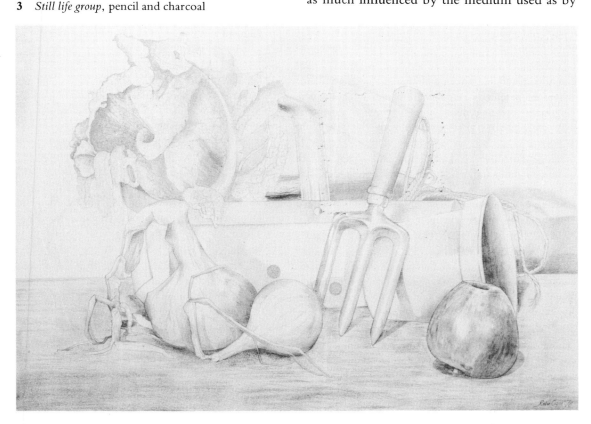

4 *Page from an illustrated study*, pen and ink

the sensitivity of the artist using it. Drawings made in a sketch book will serve an entirely separate purpose and require a different approach from those executed in the studio. Whether a sketch or a highly detailed study, whether in line or tone, whether objective, abstract, imaginative or emotional in concept, whether analytical, factual, bold or sensitive, drawing is an international language, an immediate form of communicating.

In his drawing an artist will stress certain qualities rather than others. Drawing is as much a way of seeing as it is of doing. An artist must make a judgement on what he sees and interpret this in a visual way. His understanding of what he sees may be of equal importance to the technical skill and knowledge to reproduce it. The eye must be trained as much as the hand. A good drawing will show a sensitive use of media and a confidence with technique. A great drawing will surpass the mere physical means with a vision and an impact.

The aim of this book is to promote through information and ideas on materials, techniques, approaches and subject matter, an enthusiasm and confidence in the art of drawing. Unlike many crafts, much of the equipment required is inexpensive: most people will have pencil and paper as a starting point. Bear in mind that drawing is not confined to the use of pencil, pen or any other media or technique described in this book. Any form of producing marks on a surface can make a drawing. Be prepared to experiment. Also, research those techniques which seem particularly interesting. A list of *Further reading* is included at the back of this book, refer to local libraries for others. Make an effort to look at the work of other artists and possibly learn something from them. Apart from the well known galleries and museums, some of which are mentioned in the *Acknowledgment* on page 7, many provincial museums, art galleries and country houses have interesting collections.

Materials and Equipment

A drawing consists of marks made on a surface. Most drawings are the result of using a soft medium which breaks down when applied to the support leaving a deposit in the form of lines, shapes or tones. Other drawings are carved or etched into a surface. Man has been remarkably adept in creating drawings according to the resources available. No one is a complete stranger to drawing, for it is something which children instinctively do. Unfortunately adolescence often witnesses the end of the uninhibited joy in drawing. At this stage there has in a sense to be a renaissance, a re-assessment of philosophy and a revived confidence. The process may be gradual and perhaps any changes indiscernible to those who continue to draw. However, many completely abandon drawing as a means of expression and communicating ideas. For them a renewed interest later will mean a fresh beginning.

Although the scope is tremendous, very little is actually essential to create a drawing. Before being more adventurous, the beginner is urged to keep to common materials and simple techniques. The notes on materials and equipment which follow are included to provide information and advice to help in purchasing what is necessary and in embarking on a drawing with some basic knowledge of the materials being used.

Pencils

Surprisingly, the pencil is quite a modern drawing tool, appearing in something like its present form at the beginning of the nineteenth century. Originally pencils consisted of a mixture of clay and graphite. Later, they were made of compressed powdered graphite and now they are of bonded lead or graphite. Pencils are available in a range of degrees from 9H to 7B with 'H' indicating the hardness of the pencil and 'B' the softness. The range required in most drawings will not exceed 2H to 3B. Select good quality drawing pencils. Some are marked 'hard', 'medium' or 'soft'. A very hard pencil will bite into the surface of the paper, whilst a soft pencil, such as a 5B, will respond rather like chalk. The degree marked on a particular brand of pencils may not be exactly comparable to a pencil marked similarly but of an alternative make. Also, pressure is a key factor in determining the response from a pencil, so that a line drawn with the same pencil may vary in strength from artist to artist.

The pencil is a very versatile instrument and probably more than any other medium it will reflect the expertise of the artist. Pencils react contrastingly to different paper surfaces, so it is wise to make some tests on scrap paper before committing oneself to a particular type. Other kinds of pencils are useful, especially charcoal pencils, chinagraph pencils, carpenters' pencils, coloured pencils and Caran d'ache. Charcoal pencils can be sharpened to a fine point and used for drawing in detail in conjunction with broad areas of a drawing made with stick charcoal. The medium is soft and brittle and will not take undue pressure. White chinagraph pencils are particularly useful for highlighting areas. Carpenters' pencils are very broad, medium-quality pencils suitable for laying in general tones or for sketch book work. Similarly, coloured pencils are useful for making coloured notes or sketches, or for applying tints of colour to a drawing. Caran d'ache can be used in the same way or wetted to gain a watercolour effect. These are colouring pencils of Swiss origin. They can be used in the same way as ordinary coloured pencils or, after application, can be painted over with a wet brush or piece of sponge and will then dilute to give a water colour effect. Derwent water colour pencils are similar. These are obtained from Cumberland Graphics at Keswick and are available, as are Caran d'ache, through most good stationers or art supply shops. *Caran d'ache* is a trade name.

Charcoal

Charred sticks or twigs have been used as drawing instruments for thousands of years. Formerly charcoal was made with linseed oil added to produce a deep, rich black which adheres better to the paper surface, but modern charcoal is mostly made from willow sticks and is grease free. Available in boxes, charcoal sticks

vary in length and thickness from delicate sticks to thick scene-painters' charcoal. It is an inexpensive medium ideal for preliminary studies and sketches as well as for applying large areas of grey tone in a pencil drawing. It is an easy medium to fade and to blend. Charcoal was popular in the Renaissance as a means of producing sketches and cartoons. Look at the charcoal sketch by Käthe Kollwitz, shown in *figure 5*, to see what vitality and intensity is possible with this medium.

Pastels

These are traditionally made from dry pigment bound with gum arabic. In the eighteenth century Latour and Chardin used pastels extensively for portraiture, whilst more recently, Degas experimented with pastel in combination with other media such as thinned oil paint, watercolour and pastel reinforced with tempera. In the main, pastel is an underrated medium, for it is an inexpensive, versatile and quick method of making drawings. Pastels blend easily to produce a wide range of hues, they can be applied as superimposed layers to make thick, rich areas of colour, or a pastel stick can be sharpened for fine lines and details. Pastels combine well with charcoal and can be worked over washes of ink or watercolour to make translucent tones, ideal for achieving reflections and shadows. Generally paper with a rough surface is required and it is often a good idea to work on toned or coloured paper. Keep to a limited range of colours. Pastels create a good deal of dust in the execution of the work and this must be blown or shaken clear. Spray the completed drawing with fixative to prevent further smudging.

Oil pastels are also available. These are oil-based, produce more intense colours, but cannot be smudged or blended very easily. They will mix with most other media except acrylic polymers with which they will react chemically.

5 *Self-portrait with a pencil* by Käthe Kollwitz. Charcoal on white ground, 47.6 cm × 63.5 cm sketch *Rosenwold Collection, National Gallery of Art, Washington*

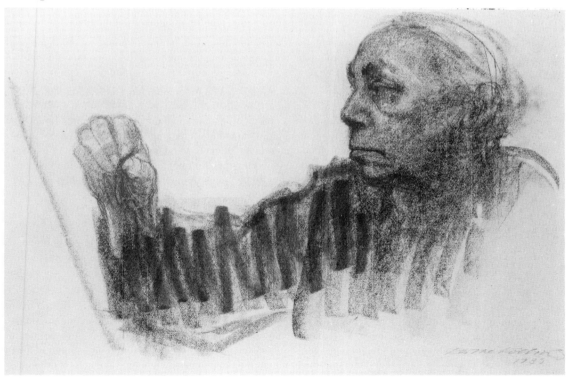

Chalks

Like charcoal, red and black chalk drawings were popular in Renaissance times for making detailed studies and cartoons. Large cartoons produced in this way would later be transferred on to canvases, panels or walls as the designs for fresco, tempera or oil paintings. Raphael made similar cartoons for tapestries. Chalk is a soft limestone substance which is found naturally in many parts of the world and is a substance which has been used extensively by the artists of northern Europe. Apart from a drawing medium it is used in making gesso to coat wooden panels prior to painting and in oil grounds to form the basis of many paint substances.

Two types of chalks are available: dust-free chalks and moulded chalks. Dust-free chalks are now made for school blackboards and are not so easily applied to paper. The softer, moulded chalks are recommended for drawing and will respond in a similar way to pastels. White chalk is

6 *Trees I: Bole and Creeper* by Henry Moore. Etching and aquatint, 23.8 cm × 18.7 cm The Henry Moore Foundation

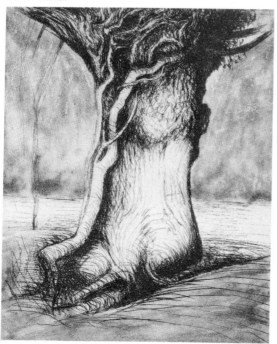

particularly useful for creating highlights in drawings made in charcoal or pencil.

Conté

Suppliers' catalogues now list both Conté crayons and pastels. The traditional square-shaped Conté crayon is a hard, grease-free drawing chalk which is usually applied to a coarse paper. It is not easily smudged and permits far greater precision than charcoal or chalk. Georges Seurat produced many drawings by this technique, see *figure 56*. Conté is also useful for taking rubbings.

Conté pastels are soft and round in appearance and behave in the same way as the chalks and pastels already described.

Wax crayons

Wax crayons are not ideal for sensitive drawing but are useful for taking rubbings and in resist techniques. The thicker, chunky black and white crayons are best. Break them into manageable lengths and use the crayon on its side for shading over large areas. Heelball wax is used for brass rubbings.

Paints

Brush drawings can be made by the direct application of paint to a suitable support whilst other drawings might include areas of wash or tints and highlights. A basic box of water-colour paints is sufficient for this purpose, though obviously sketches can be made using gouache, acrylic, poster colour or other types of paint.

Drawing inks

Coloured drawing inks for pen and wash techniques are obtainable in waterproof or non-waterproof varieties. Waterproof ink dries quickly and permanently and is not again soluble. Non-waterproof inks will dilute more easily and can be applied to almost any surface. Black Indian ink has many applications in drawing: it can be diluted for use in washes in conjunction with other monochrome methods,

it can be used with a dip-pen and it is necessary for sgraffito and similar techniques. Sepia ink is also good for pen and brush drawings, as the work of Rembrandt and Samuel Palmer illustrates.

Ink is one of the oldest writing and drawing media known to man, originating in the ancient civilisations of China and Egypt some four thousand years ago. It is a very direct medium and so is much more challenging and demanding than others. Its quick-drying nature and the fact that it usually defies erasure mean that the artist must work with speed and confidence. It combines well with pencil, charcoal and pastels and can be used in wet paper and resist techniques.

Pens

The quill pen and reed pen were the only means of drawing in this way until the nineteenth century. It is interesting to note that artists such as Van Gogh preferred these traditional techniques to the use of modern pens. Pen techniques require close working, tight control and accuracy. The quality of line produced will vary from one type of pen to another. As always, the paper or support will play a vital role. Pen lines on a smooth paper or tracing paper will be crisp and fine whilst on a heavy quality paper or blotting paper they will blur and distort. Pen and ink combines well with wash drawings and most other techniques, although over soft medium such as pastel, the pen is likely to clog.

Metal dip pens consisting of a holder and nibs of various sizes will give plenty of scope for lines of different widths and strengths. Mapping pens are ideal for fine line work. Ball-point pens, felt-pens and fibre-tip pens are useful for sketch book work and point techniques. Fountain pens and quality drawing pens such as *Rotring* will allow a continuous flow of ink for meticulous linear and detail work.

Brushes

Soft, flat brushes are required for applying washes of colour or tone, the size depending on the scale of work. For an even tone it is essential to apply the wash quickly and in general therefore the largest brush possible is used. Broad areas of wash can be applied with a 15 mm or 25 mm household paint brush whilst smaller shapes may need a small flat nylon brush or a fan brush. For fine linear work and brush drawings in ink and watercolour select a range of round, pointed sable brushes.

Always invest in good quality brushes. If they are well cared for good brushes will last a considerable time. A quality brush will hold its shape when wet and will not shed hairs. Store brushes in such a way that the bristles are not damaged.

Papers

The selection of a particular type of paper may well determine the success or failure of the drawing. Implements and media will respond contrastingly to different surfaces, whereas a grained tone or heavy texture is only possible on certain kinds of paper.

Invented by the Chinese, paper consists of a surface of interwoven fibres which may be of a vegetable, mineral, animal or synthetic material. This is prepared by being reduced to a fibrous pulp which is subsequently pressed flat to dry on wire screens. The surface of the paper, which is known as the 'ground' or 'tooth' can vary from very smooth to heavy, coarse, hand-made watercolour papers. Many papers are sized to produce a more receptive working surface. Unsized paper is known as 'waterleaf' and responds like blotting paper, making it difficult to draw on. Other papers have a 'loading' or coating of china clay and additional chemicals to give the surface texture and opacity. Such papers may be calendered or polished to produce high grade art papers. Most papers have a 'right' and a 'wrong' side. The correct side to use is the one with the uneven tooth, the reverse side having a mechanical texture derived from the screen. To distinguish the difference, hold the paper up to the light and bend over one corner. The light should show up the mechanical surface. Although either side of the paper can be used, the rigid, mechanical texture showing through

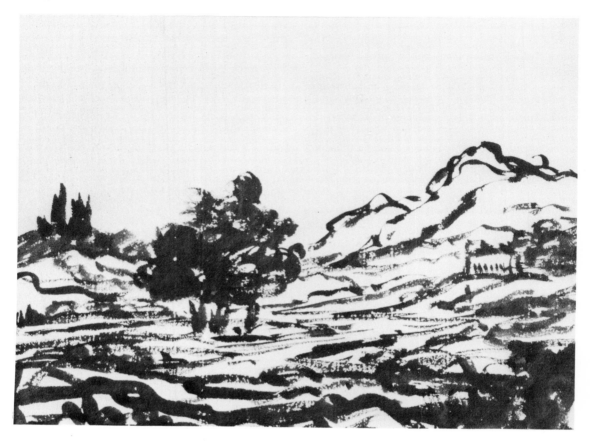

7 *Landscape* by Alexander Cozens. Brush drawing
Victoria and Albert Museum, London

an area of soft tone can be disquieting. Suppliers denote the thickness of the paper by stating its weight in grammes per square metre. Sheet sizes are in the process of standardisation to ISO (International Organisation for Standardisation) paper sizes, with the largest size being A1 (594 mm × 841 mm) and the smallest A6 (105 mm × 148 mm). Some best quality art papers and hand-made papers are still made to the traditional British sizes, with 'Royal' being the smallest (24 in. × 19 in.) and 'Imperial' being a large size (30 in. × 22 in.)

Cartridge or white drawing paper is a fine general-purpose paper. Cheap grades will fade and yellow when exposed to light and will not stand up to any vigorous treatment or stretching, so when possible, keep to medium and heavy quality paper. This is an ideal paper for pencil work. For pen work select a smoother paper such as illustration board, art paper or Bristol board. Ingres paper is available in white or weak tones, it absorbs moisture well and stretches easily, whilst Japanese paper comes in a wide range of qualities down to thin tissue for printmaking. Pastel and sugar papers are suitable for work in chalks and soft crayons. Other papers include hand-made watercolour paper, hot-pressed paper, which has a smooth, hard surface and 'not' papers, which have not been pressed but allowed to set in a variety of grades. Papers suitable for particular techniques are recommended in the appropriate text.

Sketch books

Sketch books are supplied under a variety of names: sketch blocks, drawing pads, layout

8 *Charcoal and various types of pencil*

pads, drawing books and so on. Select a book which is of the right size for the type of work you have in mind and in which the quality of the paper will suit the likely medium or media to be used. A pocket book for 'on location' sketches and notes must therefore be small and robust, whilst a layout pad for studio work can be larger and of inferior paper. In general, use spiral-bound books of thin paper with a stiff, cardboard backing sheet. If you are inhibited by sheets bound together in this way, then use a clipboard with individual sheets. Most sketch books contain sheets of cartridge paper, though some have a type of paper specifically for use with pastels, watercolour or oil paint.

Erasers

For general work a small, wedge-shaped rubber eraser is sufficient. A kneaded or putty rubber is preferable for erasing very soft pencil, chalk and charcoal. This type of eraser can be shaped to a fine point for detail work and highlights. Bread crumbs work in a similar way. Keep erasers clean by rubbing them on a scrap of paper. A badly worn eraser can be re-shaped by trimming with a sharp craft knife.

Fixative

Whereas drawing inks are permanent and oil pastels and certain types of crayons do not smudge, other media, especially if used in heavy coatings, will need fixing. Fixative is a type of thin varnish which prevents drawings off setting and smudging. It is obtainable in aerosol cans or can be applied from a bottle with a spray diffuser.

Diffusers and sprays

The traditional blow-pipe hinged diffuser is still very useful for various ink and texture techniques and is a very simple and inexpensive way of applying spray. More controlled and sophisticated spray techniques can be achieved with an air brush, although, unless it is going to be well-used, this is an expensive piece of

9 *Sketching stool*

equipment to invest in. Aerosol cans of paint have a limited use.

Boards and easels

In many instances it is preferable to work at a drawing board. This will give some support to the drawing, especially when working out-of-doors, and enable it to be propped up at different angles as required. An A2 board will be large enough for most work. Manufactured drawing boards are expensive and alternatively a piece of thick plywood with smoothed edges can be used. For some techniques a hard drawing board may seem unreceptive, in which case cover it with several sheets of thin paper first.

Studio easels are only really necessary for very large scale work, whilst sketching easels tend to be awkward and unstable for most drawing work. A table easel similar to the one illustrated in *figure 10* can be adjusted to take work of different sizes and is useful for supporting boards at an angle.

Other equipment

Additional equipment required will be determined by techniques and circumstances. The text includes references to essential equipment for particular techniques.

Ideally the drawing studio should have a solid table or bench to work at and sufficient drawers, folders or racks in which to store drawings. Good natural light is desirable, preferably from the north, as well as adequate, adjustable artificial lighting. For working outside, a waterproof folder is essential for protecting paper and drawings in addition to a carrier for other equipment. A light-weight folding stool is also useful.

Rulers, protractors, compasses, French curves and other drawing aids may be required for certain work. Add to the basic materials and equipment recommended above a good craft knife for trimming and sharpening, scissors, sponges, palettes, pins, clips and such other items as you discover to be necessary.

Mounting and framing

Not all drawings are going to be successful and indeed, one does not embark upon every drawing with the intention that it should be an exhibition piece. However, a drawing which is particularly satisfying is well worth the trouble of mounting and framing. In a sense the artist is the best person to make the mount and frame since he will have a genuine feeling for the drawing and know what will be required to enhance it and present it to the best advantage. Although everyone should be encouraged to make their own mounts, some words of caution are necessary. A mount which is badly made or is of the wrong size or colour can so easily distract from the drawing and therefore be a negative rather than a positive factor.

Mounts are usually cut from very thick card, mounting card or backing card which is available from good art supply shops and stationers. Other mounts can be made by making a laminated sheet by gluing a sheet of

10 *Table easel*

coloured paper, textured paper, fabric or hessian to a sheet of millboard or similar thick card. It is very useful to have a range of offcut strips of different types and colours so that the finished drawing can be tested against them to ascertain the best colour for the mount.

Prepare the drawing by cleaning off unwanted marks, spraying with fixative if necessary to prevent smudging and trimming to a size which allows a 2 cm margin for fixing to the back of the mount. For a drawing which runs to the very edges of the paper and has no such margins, one must either be prepared to lose the edges of the drawing beneath the mount or to first 'flat' mount the drawing by gluing it to a larger sheet of thick paper. Next, one needs to establish the proportions, colour and type of mount most suitable. If possible, lay the drawing on sheets of mounting card of different colours to determine which colour is best. Remember that the purpose of the mount is to provide a space around the drawing which assists in concentrating the viewer's attention on the work itself. Sometimes a hint of colour may liven up the drawing, but often a neutral mount of grey, sepia, off-white or possibly black is best. Having selected the colour, replace the drawing on the sheet of mounting board and move it around to discover what depth of margin is required. Traditionally, water colours, small drawings and linear drawings have proportionally wide margins. Drawings which are bold and more intense may need less of a margin and, in fact, sometimes the mount is abandoned altogether so that the drawing is taken to the edge of the frame. Measure the margin required, making the bottom margin slightly larger. Work out the overall dimensions of the card and cut out with a very sharp craft knife used against a metal straight-edge.

The drawing can be flat mounted, window mounted or double mounted. For a flat mount a sheet of backing card is prepared as above with the corners of the drawing lightly pencilled in. Working quickly and very carefully, apply adhesive to the edges of the drawing. Use a PVA or similar adhesive applied to the entire length of each edge. Leave a gap of about 2 mm around the exterior edges so that when the drawing is pressed into place the adhesive does not seep out and spoil the mount. Replace the drawing so as to align with the pencil marks on the backing sheet or card and press down. Use a piece of clean paper and work from the centre of each side pressing edges flat. Leave to dry under the pressure of some drawing boards or heavy books. The edges of the drawing may be enhanced with some ruled pen lines, as in *figure 11(e)*.

For a window mount mark the position of the drawing as before, this time allowing for the 2 cm overlap. Remove the centre square or rectangle with a very sharp craft knife used against a metal straight-edge. The edges can be cut vertically or the knife angled at 45° to produce a bevelled edge. This can be particularly effective with coloured card, since the edge will be white. Pay careful attention to corner cuts. This time the margins of the drawing are fixed to the back of the mount. Place the drawing on a clean surface, preferably a glass or plastic surface, and attach a strip of masking tape to the top edge such that half of it is stuck to the back of the drawing and half of it is showing, sticky side uppermost. Now slowly position the window mount over the drawing, lower it gradually until it seems to be in the correct place. Press down on to the masking tape. Prop up the mounted drawing to assess the positioning of the mount. If wrong, carefully peel off the tape and repeat the procedure. If correct, then tape along the other three sides to completely affix the drawing. As with flat mounting, if you do

11 *Various mounts:* (a) a mount with equal margins can suit some drawings but sometimes produces the illusion of a narrow bottom margin; (b) a mount of better proportions with a slightly wider bottom margin; (c) a 'portrait' mount similar to (b) but with the bottom edge emphasised with a thin pen line. The title of the work and signature of the artist could be pencilled on this line; (d) a double mount using two contrasting tones of card; (e) the addition of pen lines to give the illusion of recessing and to provide a bolder edge to the drawing; (f) a window mount for four small drawings. Bear in mind that the size, colour and type of mount must be carefully considered in relation to the size and force of the drawing

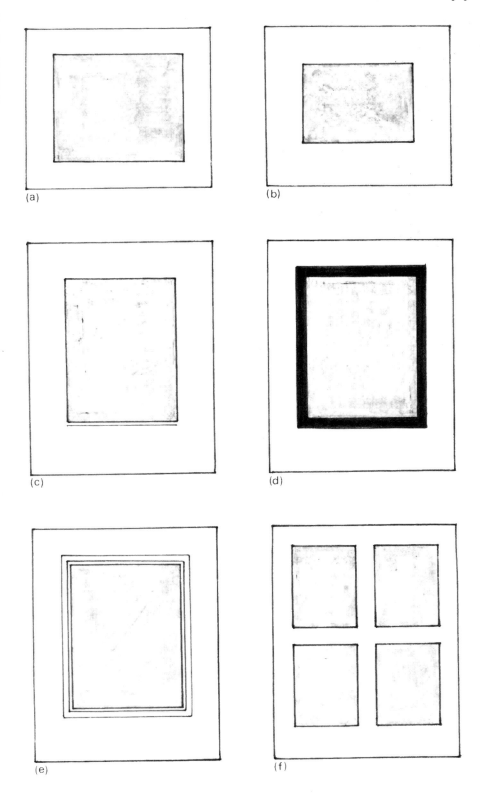

(a)

(b)

(c)

(d)

(e)

(f)

not wish the drawing to be fixed permanently, then use double-sided adhesive tape or adhesive putty instead. The drawing can then be removed at a later date and interchanged for another.

With a double mount, as in *figure 11(d)*, the inner mount is usually made from thin card or coloured paper. If prefered, window mounts can be backed with another sheet of card, though this is not really necessary if the work is to be framed.

Often the mount will be cut to fit a particular frame, though ideally the frame will be made to suit the mounted drawing. Framing is an expensive business but old frames can be obtained from market stalls, junk shops and similar places comparatively cheaply. These can be cleaned up and re-sprayed. Sometimes the glass will need replacing. Traditionally water colours and most drawings are framed under glass using a simple, thin frame. The frame can be of natural or varnished wood, or painted or sprayed white, black or gold. Obviously the frame will need to correspond to the type and colour of mount used. It is not easy to make frames unless one is prepared to invest in a good mitre-jointing device and other essential tools. Many do-it-yourself shops and glaziers will stock framing woods of different types and styles as well as cut picture glass to specific requirements. As with the mount, a shoddy job is an insult to the drawing. If you lack confidence in this work then it is well worth the extra expense of taking the drawing to a reputable craftsman or shop. See also *Further Reading*, page 116.

Techniques

Because drawing is a basic form of self-expression the ingenuity of man has led him to explore a vast range of different techniques. Often the means and consequently the technique have been restricted by what was locally available. A sunny day at a typical seaside resort in the civilised world will reveal many a young child drawing in the sand with a plastic spade or a piece of driftwood. Yet for centuries primitive nomadic tribes inhabiting areas of desert wasteland have made sand drawings. This has been one of a very limited number of forms of expression available to them. At the other end of the spectrum, the twentieth century drawing might be produced with the technological help of computers, with transfer and offset texture and tones, or by air-brush techniques. In contrast, some of the common drawing materials, such as pencils, charcoal, pastels and chalks, are much the same now as they were a hundred years ago and in some cases three or four hundred years ago.

A book is obviously limited in its scope. It would take a very extensive volume indeed to investigate all the known drawing techniques. The aim of this book is to provide fundamental information, to engender confidence with different materials and techniques and to stimulate interest and enthusiasm for the subject. The previous section dealt with tools and equipment. The objective of this section is to introduce techniques which will inspire confidence and provide experience with a wide range of media, tools and skills.

Confident drawing, although relying to an extent on knowledge and experience, is also based on practice and perseverance. Do not be inhibited by thoughts of wasting time or materials. Be self-critical and prepared to throw away unsatisfactory work. There will be moments of frustration and dejection. However, take delight in successes. When the final touch is put to a drawing which works and which gives some satisfaction and sense of achievement, all will have been worthwhile.

Linear Techniques

Probably the first line drawings were those scratched into a bare rock surface with a flint or sharp stone. Line drawings exist in all the ancient civilisations, especially those of Egypt and China. Line is the most versatile of drawing techniques. Lines can be used to enclose areas to form specific shapes or freely flowing lines might express rolling countryside or rippling water. The quality of the line is not merely dictated by the medium or technique being used but also by the response of the artist. A line can be delicate and sensitive just as it can be heavy and bold. The following pages cover a range of linear techniques from simple marks and scribble to much more sophisticated methods. Space precludes showing how each method can be adapted to different media and possibilities. The reader is encouraged to experiment in this way.

Scribble

Scribble requires a positive and deliberate action of the hand and marks a significant stage in the development of the drawing of young children. The technique demands co-ordination and rhythm. Scribbling may serve a number of useful purposes. For those who have become introspective and fussy in their work, or have lost confidence with a particular drawing implement or medium, this is a means of engendering freedom and purging inhibitions. Modern artists are not the only ones to use the technique of random scribble to suggest forms and ideas for further development, for it is said that the great Leonardo da Vinci was sometimes inspired by blot or scribble drawings. In its most controlled form the method may be used to create rhythmic design, texture or even tonal variations.

For the beginner the greatest attribute of this technique is the freedom it allows. Large drawings will encourage this. Working with chalk or charcoal on A1 sheets of cartridge paper, newsprint or perhaps detail paper cut from a large roll, will create a sense of power and rhythm in the drawing. It is not necessary to work very quickly or with obvious energy. The absence of specific subject matter with its attendant observation will mean that

concentration can be directed exclusively on the lines being made, their direction, flow, strength and intensity. Abstract drawings made in this way lend themselves to numerous avenues of exploration. For example, the initial drawing can be worked over with a different colour or implement. Experiment with 'continuous' scribble, or by using a very controlled scribble to block out the background of a silhouetted shape.

Figure 12 illustrates a contrived use of scribble to achieve various intensities of tone. This result also indicates the possibilities of the technique to create areas of texture in a drawing.

Continuous lines

Drawing tools and media impose their respective limitations and with experience the artist develops an awareness of these. In order to prevent a drawing becoming overworked, disjointed or too complex in nature, it is sometimes necessary to introduce restrictive 'rules' to confine the technique to a limited scope.

Often the imposition of 'rules' or disciplines in the creation of a work of art will add to its unity and interest. With continuous line drawing the 'rule' is that the drawing implement should not be removed from the paper until the drawing is complete, although it is possible to travel back along lines already drawn. As in *figure 13*, this will certainly test imagination and ingenuity. Like scribble, this is a technique which can also be used for pure experiment or to suggest ideas for further expansion and development. For example, allowing the line to overlap on itself to produce a variety of shapes may provide the basis for applications of tone or colour. Contrast between intense areas of line and more open shapes are an essential part of continuous line drawings. Many kinds of media may be used, possibly to a very large scale.

Such drawings will help in developing a sense of control with a particular implement. Control can be sharpened by making experiments with continuous line drawings made with the hand not normally used for drawing, or by drawing with one eye closed.

12 *Scribble drawing*, ball-point pen

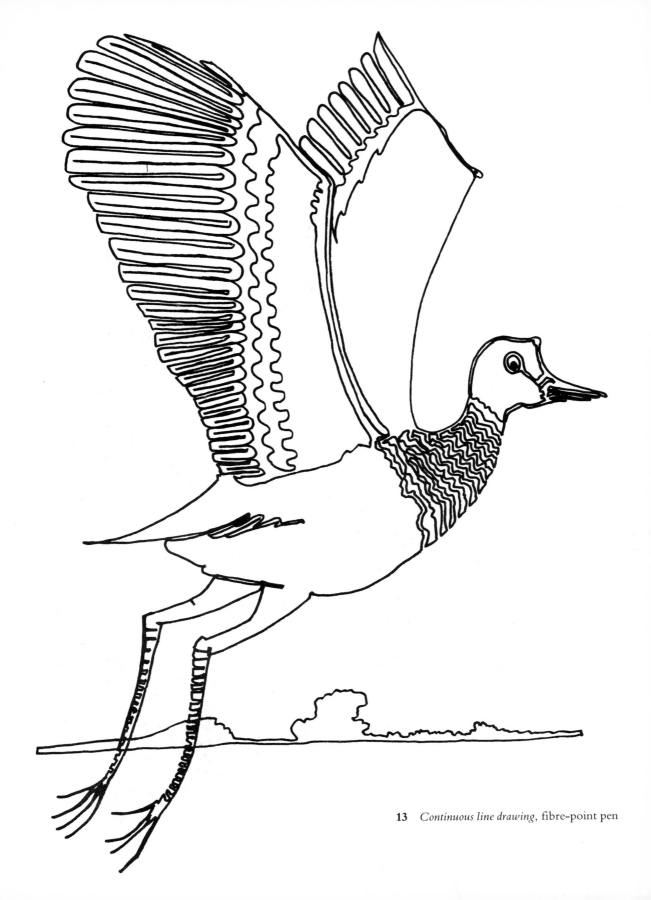

13 *Continuous line drawing*, fibre-point pen

Straight lines

This technique implies the use of a ruler or other form of straight-edge yet it is worthwhile also attempting to compose drawings by using straight lines drawn free-hand. Again, the method imposes a particular character on the drawings and encourages a confident, controlled approach. The lines employed may vary in thickness, in intensity, in length, in direction, or in spacing. Several drawing tools may be necessary to achieve these qualities. For example, whereas a stick of charcoal will produce a thick, black line, an HB pencil will contrastingly produce a thinner, grey line. In other instances the amount of pressure applied to

14 *Using straight lines*, Indian ink, fibre and felt pens

the drawing implement or medium will produce lines of different intensity, as with a very soft pencil. Similarly, varying pressure applied to a brush dipped in ink will give lines of different thickness. Fibre pens, ball-point pens, dip-pens, hard and soft pencils, Conté, charcoal and ink are all useful for this technique.

Some of the qualities possible are illustrated in *figure 14* which also employs a number of different drawing implements. Attempting an image of this type will inevitably produce a stylised result. Other drawings might be completely abstract or aim at optical effects.

Dots placed at random or at determined intervals can make an effective foundation for a line drawing. In *figure 15* dots spaced at equal intervals along all four edges of the drawing paper have been joined to common points. These drawings need to be of a small scale as accuracy and neatness are essential. The shape of the drawing paper can play a vital part in the result; a rectangular shape divided up in this way will give a totally different effect to that of a square. Numerous variations are possible.

15 *Linear design made by joining dots*

Wavy lines

Wavy lines can be drawn free-hand or with the aid of a card template. Drawings of this type are useful as exercises to encourage confidence, here with a more flowing motion of the hand, but also they can make interesting linear drawings in their own right. Again, variations of thickness, spacing and flow will play a vital part in determining the success of the drawing.

Repetition of the same wavy line, perhaps with subtle variations in spacing, can give powerful optical effects, as illustrated in *figure 16*. This was drawn with the aid of a template cut from thin card. Use a quick-drying flow pen such as a fibre tip or *Rotring* pen. Care is necessary in placing and removing the template so as to avoid smudging the lines. Indeed, such an exercise requires a patient and very careful approach. Zigzag lines using a ruler will give similar effects.

Freely drawn lines in ink and pencil have been used in *figure 17*, whilst other possibilities include designing from the centre of the sheet of paper. Such designs will be based on the repetition of flowing lines either side of the centre. Each time the line is repeated it should aim to maintain an equal distance from the previous line. Lines repeated in this way tend to gradually straighten out. These drawings are more successful on a small scale.

Repeated lines

Here again, the application of a 'rule' will give the design a particular unity and specifically suit decorative, abstract and optical treatments. The procedure is that after the bold outline shapes of the composition have been drawn in, each outline is repeated inwards until the shape is consequently filled in. Tonal differences can be achieved by varying the spacing and by using different drawing implements. For example, in *figure 18*, the darker base area is the result of much closer spacing and the use of a blacker fibre-tip pen. The flow of lines produces very interesting visual effects, often resembling wood grain.

Reference can also be made to those techniques which use the repetition of lines made with a template. See also *figure 16* and *figure 32*.

Interrupted lines

This is a technique which will be almost exclusively confined to abstract designs. Lines drawn across the paper are made to travel round any shapes they meet before continuing. Begin by making some random marks or shapes on the sheet of paper. The shapes could be small circles, triangles or other abstract shapes, though a more decorative effect is achieved by using leaves, flowers, birds or animals. Stylised patterns and more formal decorative motifs will result from the use of a template to reproduce such shapes. The lines drawn across the paper may be drawn free-hand or with a straight-edge. They are made to cross the paper vertically, horizontally or diagonally, skirting round 'obstacles' as they meet them, before continuing. Repeat the lines at close intervals and confine the work to a small scale.

An alternative idea for interrupting lines is to take a linear design and divide it by cutting so that subsequently the shapes can be rearranged or moved slightly to produce interruption to the flow of lines. Again, this will best suit abstract linear designs. In *figure 19* five circles have been cut from the original, these rotated slightly before all the shapes were glued to a backing sheet of card. In fact, in this example, each circle has been superimposed on a larger one cut from white card to achieve a shallow relief effect. Squares and equilateral triangles can be used in a similar way. Designs can also be cut into horizontal or vertical strips which can then be rearranged before gluing to a backing sheet.

Blown lines

This is a popular technique with children and one which will combine a high degree of chance with manipulative and design skills. The method is fine for small scale drawings on smooth or semi-absorbent paper, for abstract or experimental work with combined or superimposed colours, as well as for collage and découpage development.

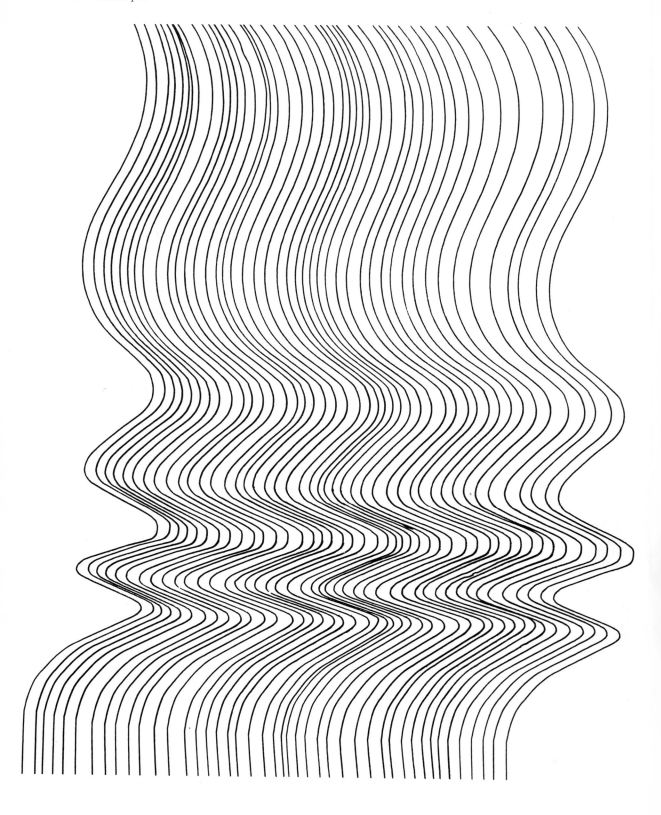

16 *Wavy line design using a template* **17** *Free-hand wavy lines*, pencil and Indian ink

18 *Repeated lines*, felt-tip and fibre-tip pens

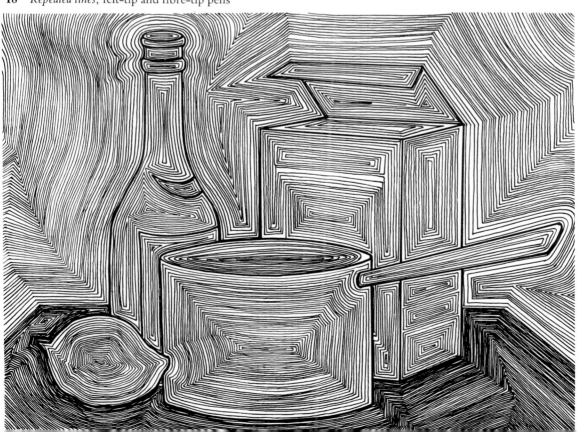

19 *Interrupted lines*

Use drawing ink or paint of a reasonably fluid consistency. First attempts might be limited to black ink or paint on white paper and be confined to experiments to discover how lines can be controlled to some extent, and what effects are possible by different blowing methods. Apply a blob of ink or paint to the paper with a dropper or by squeezing it off the end of a paint brush. These drops may be blown directly or, for a more controlled effect, by using a drinking straw as a blow-pipe. Thin, fluid paint or ink on smooth surfaced paper or card will allow for the maximum of line manipulation, whilst thicker paint on more absorbent surfaces, such as good quality cartridge paper, will be more limited in control. Drawing ink can be diluted with a little water.

One can attempt to blow the blobs of ink into specific shapes or let the first few runs of ink suggest a subject for development. It is possible to work over the initial design, when dry, with another colour, or to experiment with wet colours to exploit the intermixing of different colours and the interesting effects so produced.

Sheets of random blown lines, perhaps using different colours, can be cut into specific shapes and used in collage, as in *figure 20*. As in this example, the collage work can be developed with lines drawn in felt-tip, pencil, crayons or other drawing media.

20 *Using blown ink lines*, drawing ink and felt-pen

Linear drawings can also be made from 'runs' of ink. The lines are made by allowing drops of ink to run across the paper by tilting it at various angles. The direction of the lines can be controlled to a certain extent by altering the tilt of the paper.

Offset lines

Offset lines are most commonly produced by the 'blotting' technique or by using small lengths of card dipped in ink. Making a blot drawing is something of a chance technique; the effects can be interesting and sensitive, whilst on the other hand one has to be prepared to discard results which are badly smudged or in which the drawing fails to develop satisfactorily. Blot drawings need to be made in a free and spontaneous way and this is a good technique to encourage bold and imaginative drawing. Use a fluid or 'soft' medium to draw with so that the drawn marks can be offset on to another sheet of paper. The offset or blotted marks will therefore make a mirror image of the original ones. A sheet of paper folded in half will produce a symmetrical design, with the original drawing being transferred from left to right or right to left. Using two separate sheets of paper will produce a copy of the original in which the image is reversed; a mark on the left hand side of the original will thus appear on the right hand side of the copy.

The most reliable method of approach is to use cartridge paper which is reasonably absorbent and drawing ink. Make a few small test examples to begin with. The drawing has to be built up slowly, offsetting after every one or two marks. Apply the ink with thin brushes or pens. Offset by covering the freshly inked lines with the top sheet of paper which is then pressed down carefully and rubbed over with a finger, a piece of cloth or the side of the hand. In order that the top sheet can be exactly registered on the original each time it is important that folded sheets are folded exactly in half and that separate sheets are of identical size. *Figure 21* is a folded blot drawing using diluted drawing ink. Experiments can be made on various types of paper using different colours and media. Chalks and charcoal will also offset to a limited extent.

In *figure 22* the outline, most of the heavy tone and the body texture has been made by offsetting from a short length of card, one edge of which was dipped in drawing ink. Pour the ink into a shallow container to cover to a depth of about 2 mm. Immerse the length of card into the ink, transfer to the drawing and press down in the required place. It is normally possible to offset several lines before recharging with ink. Basic areas of texture and tone can be worked over with a more controllable medium to complete the drawing. Other items might be used to offset the ink. In *figure 23* the sky effect was produced by offsetting with a drinking straw.

Impressed lines

If a blunt instrument such as a spent ball-point pen is used to indent lines into a sheet of thick paper then it can subsequently be shaded over to produce white or negative lines against a solid background. By using two sheets of paper this technique can be exploited to give positive and negative results from the same drawing.

Monoprint drawings, as illustrated in *figure 24* use lines scratched into a bed of ink. Roll out a thin covering of water-based printing ink on a washable surface such as a sheet of glass or *Formica*. Isolate a square or rectangular area by masking out with strips of paper round the edges. Cover the ink carefully with a sheet of thin drawing paper. Do not press this down; it should be resting on the bed of ink. Draw on the top sheet of paper with a sharp pencil or ball-point pen. Only the tip of the pen or pencil must come into contact with the paper. Such lines will attract ink to the back of the top sheet of paper, so removing it from the surface beneath. The drawing completed, the top sheet is carefully pulled off to reveal a roughly corresponding ink drawing on its reverse side, as in the right-hand drawing in *figure 24*. Now cover the ink with another sheet of paper which is burnished or rolled with gradually increasing pressure. Peeling this sheet off will reveal a negative of the original drawing, as in the left-hand drawing in

21 *Blot drawing, diluted ink*

22 *Offset lines*, ink, brush and ink and charcoal
pencil

23 *Offset lines*, ink

24 *Monoprints*, printing ink

figure 24. Success with this technique will depend mostly on using the correct strength of ink to begin with and it may well be necessary to make several attempts before achieving a worthwhile result. As mistakes cannot be corrected, this is a good method to encourage bold, vigorous drawing.

For an impressed pencil drawing use a sheet of paper folded in half. Draw the design on one of the outer sides, pressing down very heavily so as to create indentations in the paper beneath. The paper is then opened out and shaded over with Conté crayon, soft pencil, charcoal or pastel. Do this lightly and evenly in several directions, building up the strength of shading gradually. On the side where the lines have been indented the lines will be left white against a dark background, whereas on the other side the lines are slightly raised and thus attract a heavier coating of crayon than the background. Alternatively two sheets of paper can be used as in *figures 25* and *26*. A design made heavily on the top sheet will impress lines into the other sheet. When shaded over, the second sheet of paper

will produce a negative of the original drawing. In *figure 26* the impressed lines have been shaded over with wax crayon.

Chalk and wax drawings are produced similarly to give interesting positive/negative results. The paper is folded in half and the right-hand coated first with a layer of white chalk, then with one of wax. It is important that the chalk covers the whole area and that no gaps are left. A coloured wax crayon may be used. The paper is then folded over and a drawing made on the top surface, pressing down heavily on to the wax coating underneath. Use a firm drawing instrument such as a ball-point or hard pencil. When the paper is opened out the drawn parts will have attracted the wax, giving a positive result on the reverse of the top sheet and negative result on the waxed sheet.

Erased lines

An eraser can make a positive contribution to a drawing and should not be regarded merely as something to remove mistakes. With more advanced techniques discussed later in this book it will be seen that the eraser can be used to

25 *Impressed drawing*, ball–point pens

26 *Impressed drawing*, wax crayon

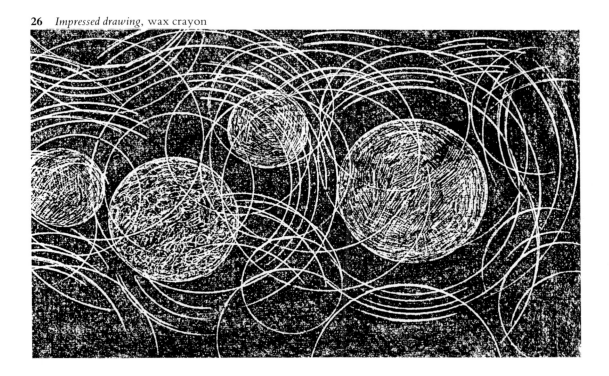

lighten tones, to put in highlights, to sharpen edges and even to stipple or texture an area. Designs similar to the one illustrated in *figure 27* will encourage the positive use of the eraser and reveal various handling characteristics. In this example the whole of the paper was first shaded in with a stick of charcoal. The lines were made by using a slice of a rubber eraser against a straight-edge. The edges of the erased lines have been emphasised with lines drawn in charcoal pencil.

Similar designs can be made on paper coated with soft pencil. Apply the pencil first in one direction then in the opposite one to obtain an even coating. A small eraser is the most suitable.

It may be necessary to clean it occasionally by rubbing it on some scrap paper.

Hatched lines

Rows or patches of short strokes can be used to build up a form or an abstract design. Tonal variations can be achieved by altering the pressure on the drawing implement or by combining a number of different media. Variations in thickness, spacing, direction and intensity will add to the interest of the drawing. The abstract drawing in *figure 28* was made by using hatched lines in conjunction with a circular card template.

27 *Erased design*, charcoal and charcoal pencil **28** *Hatched lines*, pencil and fibre pen

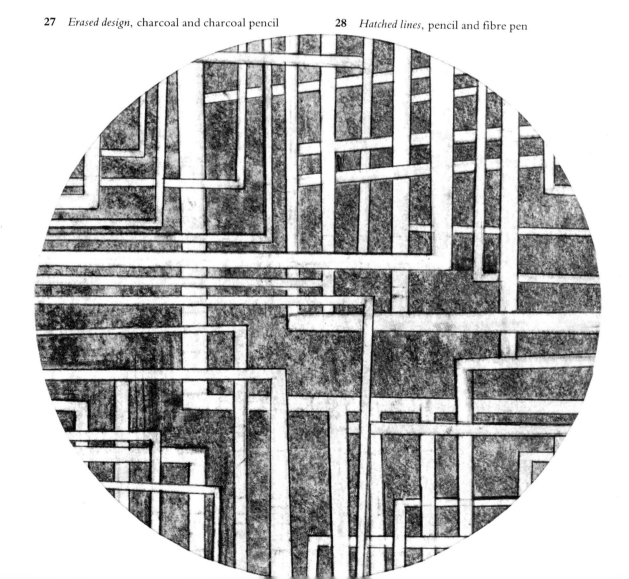

Hatched tone and hatching as a drawing technique are discussed elsewhere in this book. See also *figures 52* and *54*.

Outline drawings

The use of pure line can produce the most powerful and expressive drawing. Quite often a few selected lines can convey more force than an elaborate, perhaps overworked result. The technique is especially useful for preliminary studies and sketch book work as well as for line illustrations.

Figure 29 illustrates the potential of this technique for technical illustration. Note how the strength of the line can vary to give emphasis to some lines in contrast to others. The use of broken lines and different media are other ways of achieving contrast in the intensity of lines.

Preparatory studies for paintings can be done as brush and wash drawings, similar to that illustrated in *figure 30*. This is a quick method of working and an ideal way of tackling problems of composition and design before embarking on a detailed painting. Work to a large scale, drawing in lines freely with a brush, or applying solid tones or washes. The drawing illustrated was made on black paper using white poster colour. Several drawings of this type might be attempted before deciding on which composition to develop as a painting. See also *figure 7* and *figure 96*.

30 *Line drawing*, brush and poster paint

29 *Line drawing*, pencil and fibre pen

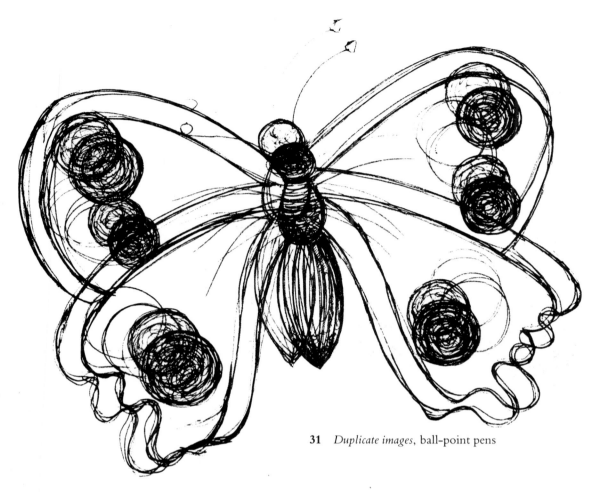

31 *Duplicate images*, ball-point pens

Several drawing instruments may be used at once so that the outline is repeated or superimposed. This can produce very interesting effects if a combination of different drawing tools or colours is used. Select two or three drawing instruments and secure them with an elastic band or hold them very firmly together. It is essential that they maintain their position and relationship to each other whilst the drawing is in progress. See *figure 31*.

Templates are useful for repeating an outline shape and constructing a linear design, as shown in *figure 32*. Cut the template from thin card and draw round it very carefully. If ink is used, ensure that lines are dry before working over them. In *figure 33* the template has been placed under the drawing paper and rubbings taken of it in varous positions. For this technique, use thin drawing paper and coloured wax crayons or Conté.

Other abstract line drawings can be made using various aids and implements such as protractors, set squares, French curves, *Flexicurves* and compasses.

Other linear techniques

The previous techniques have aimed at developing an awareness of the qualities of line as well as giving experience with different tools and media. Of course, line may be combined with other techniques such as point, wash, tone and texture, and information regarding this will be found under appropriate headings later in this book.

A variety of other methods use line as the

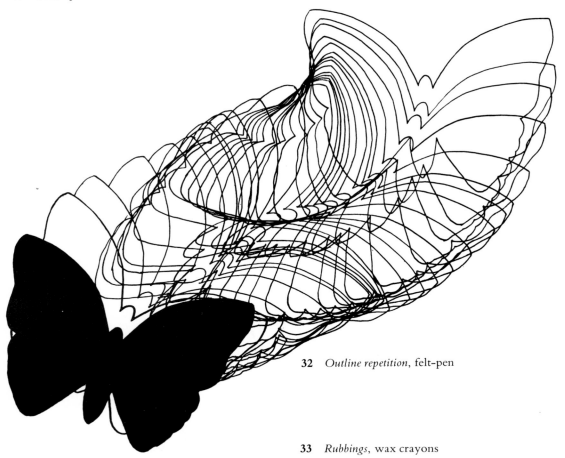

32 *Outline repetition,* felt-pen

33 *Rubbings,* wax crayons

34 *Mosaic drawing*, soft pencil

principal factor but do not fall into an obvious classification and are thus explained collectively under this heading.

Figure 34 is a mosaic drawing. These drawings must be done on small sheets of paper or card with emphasis on neat, accurate work. The drawings may be executed in pencil, coloured crayons or felt-pens. Begin by drawing in a bold outline shape such as the one illustrated. The paper is then divided into approximately 2 cm squares. Alternate areas are shaded in so that wherever possible they are bordered by an area of a different colour or medium. Where a square is subdivided, each part is treated individually. When a single medium is used it will require a certain amount of ingenuity and invention to make the 'rule' work. Even so, there are likely to be some areas in which two or three shapes of the same tone border each other.

Scraperboard is another very lively graphic technique much suited to detailed illustrative work. The board can be purchased ready-prepared from art and craft suppliers. These boards are supplied white for coating with Indian or coloured drawing ink, or pre-coated with black ink ready for use. Black scraperboard is preferable in many respects, especially for beginners. Although it is possible to correct small mistakes by blacking out with ink, it is necessary to have a good idea of what you wish

35 *Scraperboard drawing*

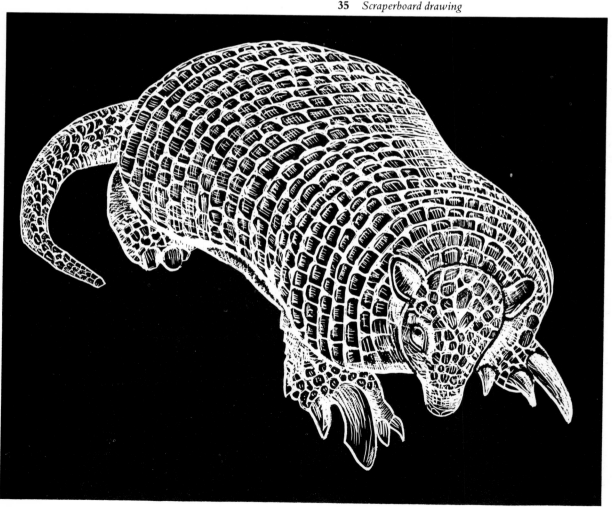

to draw before beginning. If necessary, make some preliminary sketches to work from. The lines are scratched into the black surface so as to reveal the white coating beneath. Scraperboard tools are available for this work, but any sharp-pointed instrument will do, such as a knife, a wire nail, or the pointed end of a pair of compasses. See *figure 35*.

Wax etching or sgraffito is a similar technique. This is derived from the original technique of scratching through black paint covering a plaster surface. The wax etching can produce some very colourful and exciting results and is a popular technique with children. The paper needs to be thick and strong. Cover the whole area with small patches of wax crayon. Use a mixture of any colours except black. Apply the wax thickly and in small areas or thin strips. Ensure that the entire surface is covered. Place the waxed paper on a sheet of newspaper before coating it with black Indian ink. Apply the ink with a large household paint brush. Obviously the ink will not take to the waxy surface easily and it will be necessary to paint it over several times and in several different directions to achieve a thin, even coating. Leave the inked paper flat to dry thoroughly. As with scraperboard, use a sharp, pointed instrument to scratch through the surface to reveal the colours underneath. The most effective results will be those which incorporate a good deal of detail contrasting with bolder, shaded areas, so that a reasonable amount of the wax colouring is brought to light.

For wax sgraffito follow exactly the same procedure except that the first layer of coloured wax is covered with a layer of black wax instead of ink.

I include one example of linear computer graphics, *figure 36*, to illustrate that these drawings can offer us some ideas and inspiration. A computer can be regarded as just another instrument which it is possible to use to create a work of art. On the other hand, there are those who feel that work resulting from a machine is denied expression and creative thought and that it is too clinical and cold in appearance.

Point Techniques

A number of great artists, among them Picasso, Matisse, Signac, Seurat and Van Gogh, have employed a 'pointillist' technique in some of their work. A study of these will serve to illustrate techniques as well as to inspire others. Subject matter may lend itself directly to a pointillist method. Drawings may therefore be composed almost entirely of points or dots of different sizes using variations of spacing to create an impression of depth and form.

As with linear techniques, a range of implements may be used to make the drawing. Felt-tip pens, fibre pens, ball-points and pencils are the most obvious, though dots can also be offset with fingers, dowel and the blunt, round ends of pencils or paint brushes. Paint can be dropped, sprayed or flicked and designs can be built up with stamped point or can be typed. There are many possibilities to exploit.

This is a technique which has limited use in objective work and careful studies. Rather, it is one which will interpret a particular texture or feeling of light or create a subjective impression. Look at the paintings of Georges Seurat to see how atmosphere and light and dark can be achieved in this way. In many of the later drawings of Van Gogh point and line are combined to give lively drawings of great power and contrast.

Point here is taken to include those techniques which produce marks approximating to round dots as well as those using short 'stabs' of tone or colour or made as the result of flicking, spraying or dropping liquid medium on to a sheet of paper.

Offset and impressed point

As an introduction to these techniques it is useful to experiment with various implements to discover ways in which points or dots can be made and the limitations and characteristics of each method. Try dowel, fingers, brushes, drinking straws, ink and paint as well as the more obvious drawing tools. *Figure 37* shows a range of sizes of different types of point. As in rows from the left of the illustration, these were

36 *Computer graphics*

made with fibre-tip and felt-tip pens, the round end of a pencil (row 4), a finger (row 5), dowel (row 6), and a small cardboard tube.

Impressed point is made by taking a drawing tool, holding it vertically, and pressing it down on to a sheet of paper to create a mark. Drawing tools such as felt-tip and fibre-tip pens, *Rotring*

and other drawing pens, soft pencils, charcoal pencils, crayons, chalks and charcoal are best for this since they do not need re-charging with medium. The size of the point and the strength of its tone will depend on the implement being used. Felt-pens and soft pencils can be used with a very quick stabbing motion to build up a dotted texture or tone. Look at *figure 38* to see how spacing plays a vital role in suggesting tone.

Offset point is made by dipping a round

37 *Different types of impressed and offset point*

implement in a shallow quantity of ink or paint, transferring this to the paper, and pressing it down in the appropriate place. Experience will determine how much ink to use with a particular implement for some will absorb it more than others. Similarly, the amount of pressure required to offset the point will vary. Mix the ink or paint in a palette or small, shallow plastic tray. It will be necessary to re-charge the implement with ink after every one or two impressions if an even strength of tone is required. Select a heavy cartridge drawing paper or similar slightly rough and absorbent paper for this work. The impressed area may constitute just a part of the whole drawing as in *figure 39* where the rocky foreground has been made by offsetting ink with a finger.

Point and line

Many of the ideas and methods already discussed are adaptable to a combined use of point and line. This applies to both representational and pure abstract work. Joining dots is an obvious example of this combination and was illustrated in *figure 15*. Point and line is a good 'short-hand' technique to employ in sketch book work where speed is essential to capture as much information as possible. In *figure 40*, notice how dots can be spaced to suggest distance and movement whilst, similarly, shorter lines recede in contrast to the bold lines of the foreground.

Spraying

Spraying will normally produce a fine, even application of point suitable as an interesting, general textured ground or, if isolated by masking, for specific areas of the drawing. As a preliminary treatment of the paper it can be overworked with various media, including pastels, inks and paints. Sprayed point can be applied with a diffuser, an air-brush, a paint spray-gun or by using aerosol tins of paint. For small drawings the diffuser and air-brush

38 *Point drawing showing different intensities*

39 *Offset point and pencil drawing*

40 *Point and line*

41 *Sprayed point and line*

techniques will suit best. Use drawing inks or diluted paints. For a fine spray, work from a distance of about 450 mm. Make some preliminary tests on newspaper or scrap paper to ascertain the colour and the strength of application.

Figure 41 was produced by using a paper template to isolate a shape against a sprayed background. Cut the template from thin paper and position it on the drawing paper. Use good quality cartridge paper or water-colour paper, otherwise stretch the paper to avoid wrinkling and distortion. (Figure 63). Hold the template or mask in place by using *Cow Gum* or a few small pieces of *Blu-Tack*. Pin the drawing paper to a board and prop this up at an angle of about 30°. If a good drawing board is used, cover this with

newspaper first. Likewise, cover all the surrounding area of work space with newspaper to protect it from spray drift. Spray from left to right and from top to bottom with a fairly quick motion. Directing the spray on to one area for any length of time will cause a heavy accumulation and probably make the paint run. Spray in thin coats, allowing each to dry before the next is applied. Build up the intensity of spray desired in this way. Near spraying will usually produce larger speckles of ink or paint than that done from a distance. Do not remove the template until the spray has dried. If the template is attached correctly it will ensure a clean, neat edge to the sprayed area. If it is not held down securely, spray is likely to penetrate around the edges, producing a less defined image.

Whereas *figure 41* uses a silhouette-type mask

42 *Sprayed and impressed point*

and a close, heavy spray, the example in *figure 42* uses a more elaborate mask and much finer spray. Here, the headlamps and window areas have been cut away to allow the spray to penetrate. The spray is combined with other point techniques using fibre-tip and felt-tip pens.

Other point techniques

Point can also be applied by dropping, flicking, splatter and stippling techniques. With the exception of stippling, these are not very controllable methods but are suitable for abstract or experimental designs as well as those which use a stencil to confine the technique to a particular area. *Figure 43* was produced in this way. Use thin paint or drawing inks applied by brushes of different types.

Prepare the drawing and the surrounding work area by masking out as necessary. Mix the ink or paint in a small jar or similar container which will allow complete immersion of the hairs of the brush up to the ferrule. The brush is therefore heavily laden. For flicking, use a soft-haired brush, holding the brush horizontally over the paper and either apply the paint by making a sharp flick of the wrist, or tap the stem of the brush sharply with the first finger of the other hand. Interesting effects can be achieved

by flicking paint on in various directions and by exploring possible contrasts between colours and the thin trails of paint caused by using brushes of different sizes. Each colour may be left to dry before the next is applied, or, if a mottled effect is desired, apply a new colour directly on to wet paint. For dropping, the technique is similar except that the brush is held vertically and the paint released by a sudden, downward thrust of the hand.

The splatter technique requires a hog hair or other stiff-haired brush with a drier, sparser application of paint or ink. Hold the brush horizontally over the drawing, gripping it quite near the ferrule. With the first finger of the other hand pull back the hairs of the brush so as to create a fine spray of ink or paint on to the paper below. Select old brushes if possible, as brushes subjected to this treatment are likely to loose their shape! Old tooth-brushes are ideal.

Special stencil or stippling brushes are obtainable from suppliers, these having short, stiff hairs. In the absence of these it is possible to make a suitable brush for stippling by cutting down the hairs of an old hog hair brush with a sharp craft knife so that they measure about 1 cm in length. Use a reasonably large brush, say a no. 10 or no. 12. This time, mix the paint or ink in a shallow container so that only the very tips of the hairs attract any of the medium. Use the brush vertically, lightly stabbing it down on to the paper to offset the paint. As with all of these

43 *Various point techniques*

techniques, do some test examples first. Good stipple will be the result of a very limited amount of paint on the brush combined with just the right amount of pressure.

Wash Techniques

Wash drawings are normally made with a brush using different tones or colours of ink or paint. This is an ideal technique to employ for making studies, particularly of landscape, which are later to be worked from for larger compositions in oils or other media. General areas of wash can be combined with other drawing techniques or used as a base to overwork in other media to add greater detail and definition.

The traditional way of using wash is to regard the white of the paper as the highlight, then to apply transparent washes one over another in order to achieve gradations of colour or tone. It is usually necessary to allow each colour to dry before applying the next wash, the gradual accumulation of paint giving variations in the richness of colour and the depth of tones. Alternatively, the wash may be applied to individual areas of the drawing as a separate tone with no overpainting. It can be applied to a wet base or against a wet edge and allowed to infuse with it. Whilst the wash is still wet it can be scratched into with the blunt end of a paint brush or similar instrument. When dry, it is possible to work over the area with chalk, pastels, charcoal and other media. Wash can be used in resist techniques such as in combination with wax or oil-based crayons.

Water paints or drawing inks are the most suitable media. Indian ink is especially good as once it is dry it is permanent and thus successive washes can give a glazed effect. Also, it can be

diluted with water to produce a great range of tones. Brushes of different types and sizes, rags, sponges and tissue paper are useful for applying the wash. Paper of a reasonably absorbent character is required; good quality cartridge papers are suitable as well as the heavier papers recommended for work in watercolour. Paper which receives a lot of wash may wrinkle and thus become difficult to work on as well as presenting problems when mounting or framing. For work other than quick sketches and studies it may therefore be advisable to stretch the paper before use as described on page 73.

Some preliminary exercises with brush and wash will give confidence and stimulate fresh ideas. Different brushes will produce different effects, though it is surprising what results are possible with a single brush if used skilfully. Increasing the pressure on a soft brush, for example, will cause it to splay out and give a wider area of wash. *Figure 44* shows a range of techniques using ink, including stippled, sprayed and sponged effects at the top, as well as the use of a stiff-haired brush giving a characteristic striated effect. The lower four sections show various tones from diluted Indian ink applied with a flat, soft brush. In *figure 45* black drawing ink has been 'worked out' from the bottom upwards, using a flat brush dipped in water.

Pencil and wash

Ensure that the drawing paper is stretched or is of a quality which will not wrinkle unduly when wetted. Use diluted Indian ink and apply the wash quickly with a flat brush. This is an ideal way of laying in a large area of tone and useful for sketch-book work as well as in studies and drawings. Thin wash will allow bold pencil lines to show through, whilst similarly, it is possible to work over a grey wash with soft pencils and charcoal pencils. The painterly quality of the wash can be used as deliberate contrast to more rigid lines of drawing. See *figure 46*. In the still-life illustrated in *figure 89,* the bottle is developed as areas of wash.

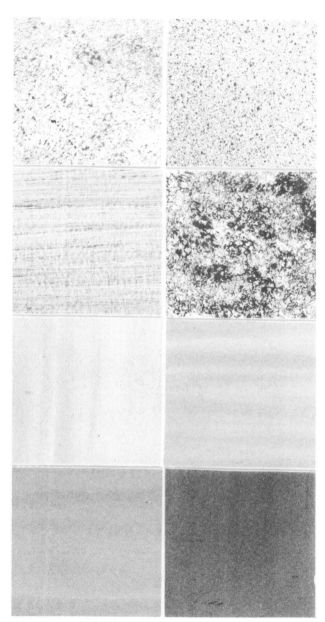

44 *Various wash effects*

45 *Variation of tone*

46 *Portrait of a Lady* by Gwen John. Pencil and grey
wash, 25.44 cm × 17 cm *Reproduced by courtesy of
Davis and Long Company, New York*

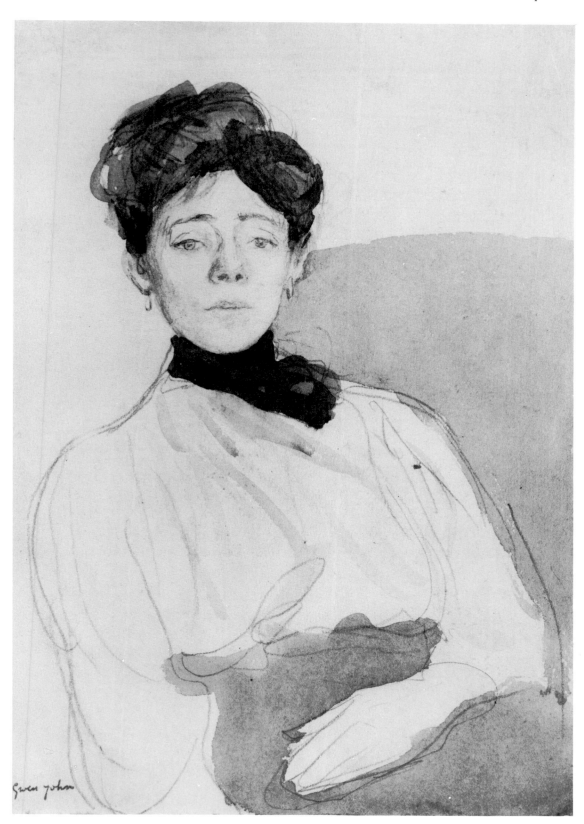

Pen and wash

Pen drawing will require a paper of a smooth tooth or finish and the paper will most likely need stretching prior to use. Alternatively thin card or fashion board can be used. The wash is applied as general tones or as a background and is subsequently worked over with various pens to add detail and hatched or heavier tone. Different kinds of pens may be used: mapping pens, dip pens with nibs of various widths, fountain pens, *Rotring* and other drawing pens, felt-tip and fibre-tip pens, and ball-point pens. The method is particularly suited to illustration work as shown in *figure 47*.

Brush and wash

Wash areas can be contrasted with more detailed brush work. Such drawings may be in a single tone or incorporate gradations of tone and a succession of washes. In *figure 48* three stages in the development of a wash drawing are shown. The white paper is left for the highlights and the first wash becomes the lightest tone. This is worked over where necessary with subsequent washes to build up the strength of tone required. Allow each wash to dry before applying the next and preferably work on good quality water colour paper. Final details are added with a very fine brush or a well-sharpened charcoal pencil or other soft pencil.

Other wash techniques

Wash may be applied in a number of other ways. Sponges of various sizes and textures are useful

47 *Pen and wash drawing*

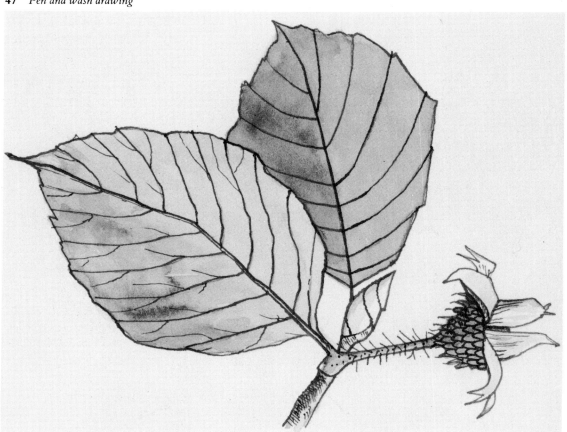

48 *Brush and wash drawing*

for laying in large areas of wash and for stippling. Wash can also be applied with tissue paper or small pieces of rag. These may be used to dab on paint or ink, or perhaps to wipe them on lightly. Tints of colour can be achieved by using coloured tissue paper which has been dipped in clean water. Areas of broken tone can be stippled or sprayed in using techniques previously described. See pages 49, 52, and 53.

The contrast between ink techniques and watercolour techniques is illustrated in *figures 49* and *50*. *Figure 49* uses masking and spraying, stippling with a sponge and brush, as well as wash and pen and ink drawing. The entire drawing was made with black and white drawing inks. *Figure 50* combines washes of watercolour with stippled areas and brush work.

Tone Techniques

Tone is used to effect contrasts of light and dark, the modelling of form, the illusion of depth and something of the character of the subject. Tone is essential shading done to create an impression of the third dimension. There are many ways of making tonal drawings and the artist can select a method which suits his interpretation of the subject matter.

As always, it is wise to begin by experimenting with a wide range of drawing tools and media. Changes of tone may be achieved by using a combination of different media or simply by variations of pressure with a single drawing tool. Preliminary exercises to exploit the character and possibilities of a particular medium will give confidence and serve as a useful introduction to more complex work. *Figure 51* shows how different media applied with a similar moderate pressure respond to various qualities of paper. Notice the range and character of the tones produced. In rows from top to bottom and left to right, these are: hard pencil and soft pencil on inferior cartridge paper; Conté on cheap paper and charcoal on heavy quality paper; wax crayon on heavy paper and ball-point pen on thin cartridge; wax crayon on smooth paper and charcoal

Overleaf
49 *Various ink wash techniques*

50 *Various paint wash techniques*

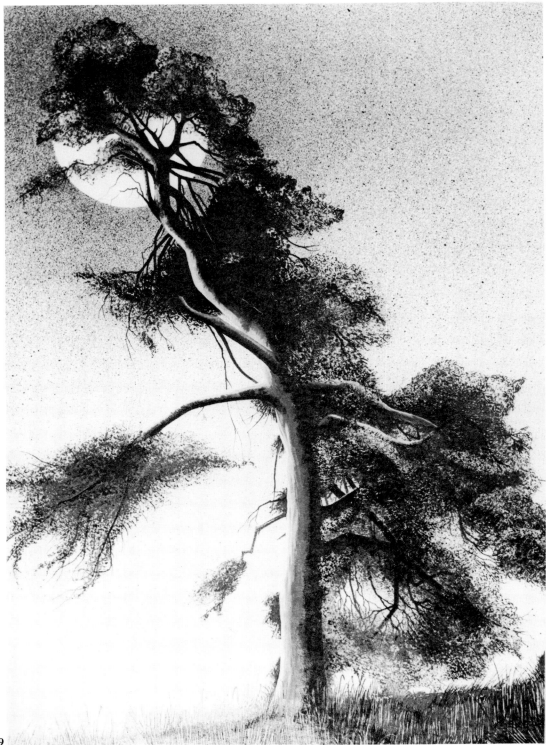

49

50

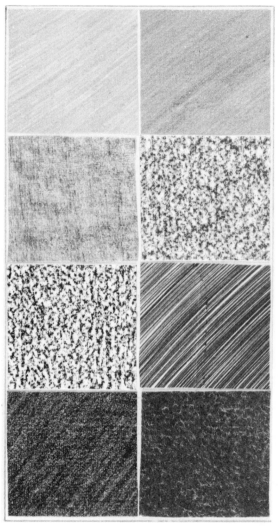

51 *Different tonal intensities*

52 *Different shading techniques*

applied with a heavier pressure on thick cartridge. *Figure 52* shows a variety of shading techniques; similarly, note the tone produced and the character of the different surfaces. Likewise, in rows from top to bottom and left to right, these are: linear shading from dark to light and hatched shading with a soft pencil; crosshatching and offset shading; chiaroscuro effects with soft pencil and charcoal; hatched ball-point and a solid dark tone in ink.

Linear tone

Lines grouped together can give an impression of tone, with the strength of the tone varying according to the spacing and pressure used. Such lines may be short (hatched) or long, they may

53 *Head of a Man*, by Honoré Daumier.
Wadsworth Atheneum, Hartford, Connecticut, USA
Gift of Henry Schakenberg

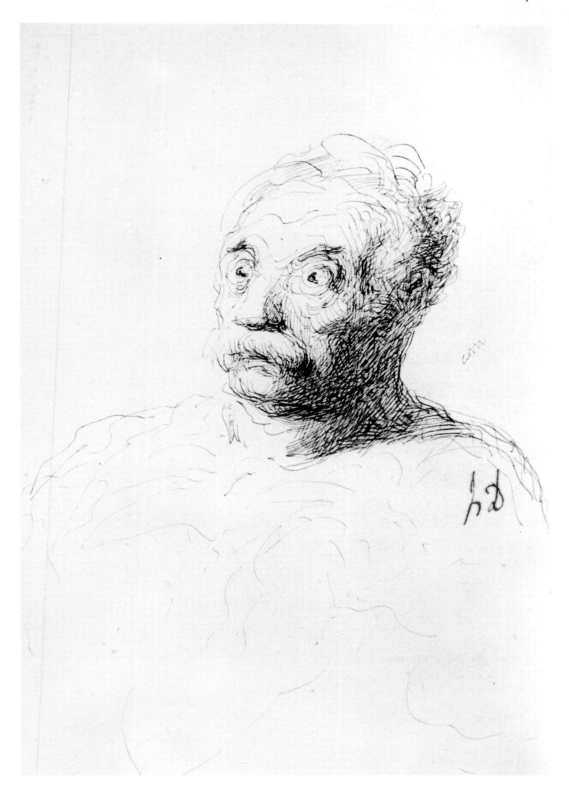

be drawn free-hand or ruled, or they may be superimposed by others in a different direction (cross-hatched). Usually a strong tone is achieved by placing bold lines closely together or by cross-hatching. Conversely, faint lines used wider apart will give a weak, open tone. Combinations, both of techniques and media, may be necessary within a single drawing. As always, the nature of the tone imposes its distinct characteristics on the drawing, but with skill, subtle changes from light to dark are possible. Eighteenth and nineteenth century etchings illustrate these linear techniques very well.

The use of freely drawn overlapped and superimposed lines is illustrated in the drawing by Honoré Daumier, *figure 53*. *Figure 54* shows the use of hatched and flowing lines of different spacing to achieve contrasts of tone. Heavy tones have been built up by cross-hatching and

by using a softer, and consequently darker, pencil. Hatched lines are usually short and will give work of a vital, lively character. Various layers of hatching will give a solid area of tone with no hint of the linear way in which it was obtained. Similarly, edges can be 'lost' by a gradual fading out of cross-hatched lines.

Shading can also be made by a scribble method applied with a circular motion, as shown in *figure 12*.

Offset and erased tone

Some of the most subtle tonal effects are obtained by offsetting or by techniques involving smearing, smudging or rubbing.

The gradual transition of tone from light to dark is sometimes essential to convey a particular lighting effect or surface characteristic. Leonardo da Vinci said that light and shadows should blend 'without lines or borders, in the manner of smoke'. It was during

54 *Hatched drawing*, pencil

the period of the High Renaissance that the technique of shading known as *sfumato* was developed. Sfumato comes from the Italian word 'sfumare', meaning to evaporate, and is used to describe the transition in tone by such gradual stages as to be indiscernible.

To achieve such effects, a soft drawing medium must be used so that edges can be 'lost'. Soft pencils, charcoal, chalk and pastels are ideal media. The fading out of tone can be made in a number of ways. The shading in *figure 55* was done by smudging and offsetting with a finger. Use a soft pencil of at least 2B quality on smooth cartridge paper. Apply the dark tones first, then lightly rub these into the surface with a finger and at the same time work them outwards to fade. Clean up the edges and remove surplus tone with a soft eraser such as a putty rubber. Shading made by a cross–hatching method can be smoothed out or faded in this way. A finger can also be used to offset darker tone from one area and build up light tones in other areas. Again, lightly rub the finger into the heavy tone, but this time transfer the medium which has been offset on to the finger to another area and rub it in as a light tone. In fact, this need not be from one area of the drawing to another, but could be from medium deliberately applied to some scrap paper for the purpose of offsetting. Similarly, a dirty eraser can be used to rub light tone across an area. With all of these techniques the quality and texture of the drawing paper must be considered. Charcoal and chalk, for example, will require the use of heavier paper. Should there be any doubt as to the suitability of a particular type of paper it is advisable to make some simple tests on a scrap piece of the same type.

To create a very soft line or to lessen the strength of a line gradually, it is often easier to draw it in first quite boldly and then lightly drag an eraser over it. An eraser is also useful for phasing out tone and for softening edges. Use a very soft, putty rubber for these techniques, dabbing it on where necessary. Highlights can be achieved by using a small, clean slither of a rubber eraser to rub out the relevant parts from an area which was previously covered with some form of tone.

Accumulated tone

An alternative way of creating gradations and contrasts in tone is simply by making variations in the build up or deposit of a particular medium. A heavy coating will give dark shadows whilst a lighter coating will create intermediate tones. Use a soft drawing medium such as charcoal, pastel, chalk, Conté or very soft pencil, on a suitable drawing paper.

The tonal properties of a number of different media can be exploited in the same drawing. A medium may be selected primarily for the natural tone it produces. Hence, a dark tone will be obtained with Indian ink, whilst a very soft tone could be made with a hard pencil or a light application of charcoal. Some media work well in producing a balanced range of tones, for example, ink, charcoal, charcoal pencil and pencils. See *figure 56*.

Texture Techniques

Texture in drawing is a quality which appeals to the vision rather than to the touch. With drawing techniques it is seldom possible to achieve impasto effects and thus a drawing cannot have the same tactile qualities that might be found in a painting, on a piece of pottery, or on a length of woven fabric. Textured areas can be used to relate directly to the surface characteristics of the subject being drawn or they can provide interesting contrasts to other methods of drawing.

The methods of working will depend on various factors and must be planned in relation to individual drawings. It is not always possible to isolate a particular shape of texture and therefore it may be necessary to apply a general texture which is later worked over. Alternatively, parts may have to be masked out before texturing. The surface might have to be prepared in some other way: the texture might, for example, be applied over an area of light wash. *Figure 57* shows a small range of textures produced by various means. In rows from top to bottom and left to right, these are: a Conté rubbing of textured hardboard on thin cartridge

56 *Portrait of Paul Signac* Georges Seurat. Conté
crayon, 34 cm × 28 cm
Collection Mme Ginette Cadin-Signac, Paris

55 *Offset and erased tone*, soft pencil

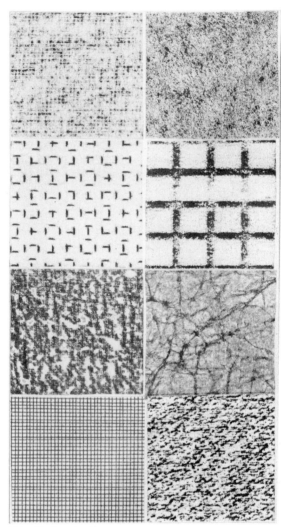

57 *Various textures*

rubbing, place a sheet of paper over the textured surface and hold it firmly in place whilst the crayon is rubbed systematically across it. The crayon is used on its side and it is usually best to rub it across in one direction and then in the opposite direction, applying pressure gradually. With deep textures, take care not to tear the paper.

Stippled and sprayed texture

Texture made by stippling or spraying techniques may easily be confined to certain parts of a drawing. Stippling is done with a stiff-haired brush used in a fairly dry state. Interesting grounds are obtained by spraying using thinned paint or ink applied with a spray diffuser after the necessary areas have been masked out. These techniques are described fully on pages 49 and 52.

Various textural effects are used in *figure 58*. The background is sprayed in ink and subsequently worked over in part with pastels. The bird has texture applied by stippling, hatching and point techniques. Note the variety of media used here: pencil, charcoal pencil, drawing ink, pen and ink and pastels.

Resist techniques

Very interesting textural effects can be made by using watercolour washes over areas previously treated with wax. Ordinary wax crayons are perfectly suitable for this. Block out the desired shape first with a layer of wax and then apply a thin wash of water colour or ink with a flat brush. The wax will do its best to repel the watercolour and cause it to collect in unpredictable globules and shapes. Such textures may require an extensive drying time. A combination of water-based inks or paints with oil pastels will work in a similar way. See *figure 59*.

paper and stippling with drawing ink; two wax rubbings of metal surfaces; wax resist (that is a water colour wash over a waxed area) and shaded crinkled paper; ink lines and wax crayon applied to coarse paper.

Heelball, wax crayons, Conté or chalk are the most useful for taking rubbings. Cartridge paper is generally suitable, but thinner quality paper such as newsprint can be used if the texture is shallow or elaborate. When selecting the paper one must also consider its suitability for other types of drawing if the rubbing is to be combined with other techniques. To take a

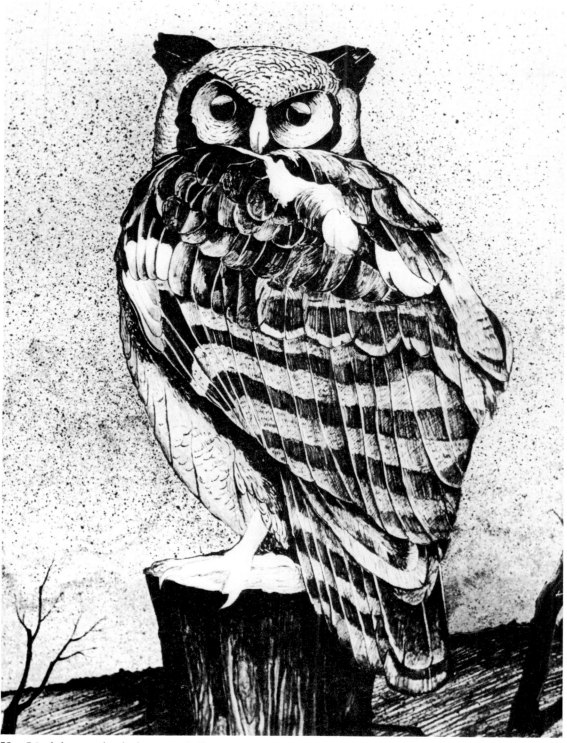

58 *Stippled, sprayed and other textural effects*

59 *Two seated figures* by Henry Moore. Pen and
chalk drawing with water colour washes over wax,
18 cm × 27 cm
Tate Gallery, London

Approaches

Before the first, tentative marks are made on that awesome sheet of white paper, a number of important decisions have to be taken. Such decisions are not merely concerned with the technical aspect of producing the drawing, but perhaps of more consequence, the aims of the drawing and how the subject matter is to be interpreted. It can be argued that too much preparation will destroy the spirit of drawing and negate any emotional involvement. Equally, a lack of adequate planning may lead to frustration and disappointment. The purpose of this section of this book is to bring the reader's attention to issues which may need some thought before undertaking a drawing. Some of the main topics for consideration are covered in the following pages, though space precludes any lengthy dissertation. Points of particular interest can be followed up by referring to books which specifically cover these matters. The list of *Further reading* on page 116 includes a number of titles concerned with the philosophy and approach to drawing as well as those on composition, perspective and other devices. The reader is also encouraged to go and look at the rich variety of drawings by many great artists displayed in museums, galleries and other public and private collections.

General principles and considerations

The sketch books and note books of Leonardo, Rembrandt, Van Gogh and many other artists reveal a vision, commitment and an insatiable quest for knowledge and information about different subject matter. We can be encouraged and inspired by these great men. Knowledge is an important aspect of drawing. If we understand something of anatomy we are more likely to master life drawing, if we appreciate the influence of light on a cylindrical metal form we are better able to draw it convincingly, whilst our knowledge of perspective helps us to achieve the illusion of distance. Such knowledge is not obtained instantly or easily, but rather at the expense of much practice, perseverance and enthusiasm. As a beginner, it is wise to make drawings of familiar items, events and scenes so that what information is known about the

subject matter can strengthen the drawing. Select subjects with which you have some sympathy but which are also challenging. Never make assumptions about what is to be drawn. Regard each drawing as a new experience. Look at the most commonplace object as though you had not seen it before.

With increased experience it becomes possible to perceive the general aims of the drawing and visualise the intended result. Peculiar characteristics, surface textures or light and dark effects might themselves suggest a particular technique by which to satisfactorily express the subject. However, drawing is more than just representing what is there. The trained eye will question what it sees and develop and interpret it. Not just our skill but our discernment, opinions and emotions will influence how we draw.

The three examples illustrated in *figures 60 to 62* show different ways of interpreting relatively similar subject matter. *Figure 60* shows the more subjective and emotional response as well as the most straightforward in approach. This is a coloured drawing in mixed media in which the stark trees are silhouetted against the dying, winter sky. The aim here is not just to capture reality but a particular mood and atmosphere. Contrastingly, in *figure 61*, an analytical approach is adopted where the shapes and blocks of tone within the subject matter become of prime interest and move the drawing away from reality. A process of persistent analysis and simplification in this way would produce a totally abstract result. *Figure 62* is a brush drawing using washes of watercolour. Here, the technique is allowed to dominate and dictate the way the drawing evolves.

Preparation for drawing

It is obvious that before beginning to draw it is prudent to check that all media and items of equipment likely to be required are available and in good order. In addition, for certain techniques, it may be necessary to prepare the drawing paper in some way. If the drawing is to include wash techniques or other methods likely to wet the surface then it is advisable to stretch

60 *Landscape drawing*, mixed media

the paper first. The only exceptions will be heavy-quality watercolour paper and card. Stretching paper is illustrated in diagrammatic form in *figure 63*. Have ready a drawing board, a sponge and lengths of gummed brown tape. Soak the sheet of drawing paper in clean water, either by holding it under a tap, applying water to it with a sponge, or as shown in *A*, by passing it through a tray of water. Place the wet sheet of paper on a drawing board, as *B*, and apply wetted strips of gummed tape around the edges, as *C*. The strips of tape should be long enough so as to overlap and be folded under at the corners. Large sheets of paper may require two strips to each side. Ensure that the corners are neat and secure, as *D*. Leave the paper to dry out thoroughly. When the drawing has been completed the paper may be carefully removed and trimmed to the desired size.

Other drawings may require an initial application of wax, spray, texture and so on. Card can be sized prior to use. The drawing paper should be large enough to allow a margin for mounting or framing.

Composition and selection of subject matter

A drawing which is bound by the rigours of formal composition is unlikely to be entirely successful. Drawing must not resort to a routine, with all the problems having been solved in the planning stage. The artist must be free to seize on those moments of insight and vision and develop and manipulate the drawing accordingly. Composition is a rather general term which is open to a number of interpretations. Like perspective, it is an aspect of drawing which the artist should be aware of

62 *Landscape view*, brush

61 *Tree studies*, pencil

63 *Stretching paper*

but which will not consciously dictate what he does. Composition is as much a matter of intuition and opinion as it is of skill and reasoning.

Good composition is dependent upon deciding how much to include in the drawing as well as how to arrange or combine the various elements of it into a coherent visual whole. In its simplest form composition might be just a matter of achieving a balance between drawn areas and the surrounding space. In a still-life or life study the fundamental problem is one of proportion and scale, simply aiming to fit what is to be drawn on the selected sheet of paper. Other work may have to consider symmetry and asymmetry, balance and contrast, the distribution of light and dark or line and texture and so on. One way of discovering something about composition is to analyse the work of some of the great masters. Many paintings use a contrived composition based on a proportion known as the golden section or golden mean. This is a mathematical proportion accepted by many as having aesthetic virtue and which in practice amounts to a division of the basic picture rectangle in the ratio of 8:13. Look at the work of Claude and Poussin, for example, to illustrate this. The earlier Renaissance *Madonna*

and Child paintings placed great emphasis on a triangular composition whilst, in contrast, the *Last Supper* by Leonardo is designed to draw the viewer's attention in to the central figure of Christ. Later paintings by such artists as Toulouse-Lautrec, Van Gogh and Matisse use much more spontaneous and intuitive means of composition. In all drawings the design should be such that it provokes interest in the completed work. Often the design will dominate in this respect.

Figures 64 and *65* serve to illustrate a number of points. Especially with a landscape view, like the camera, we need to isolate a specific area for consideration. The photograph shows the view as we would see it in reality. If we so wish, we can accept this as it stands as the basis for our composition. However, this particular view deliberately contradicts techniques of composition which are generally accepted as bad. The line of the horizon divides the picture almost exactly in half horizontally, whilst the large tree, which is the main element of the design is on the vertical centre line. In theory such a picture would be too symmetrical and therefore lack interest. In practice, such events can often be compensated by other elements. In this view the vertical balance of the large tree is counteracted by the various smaller trees to the right of it. These, and the focal point of the

64 *Location photograph*

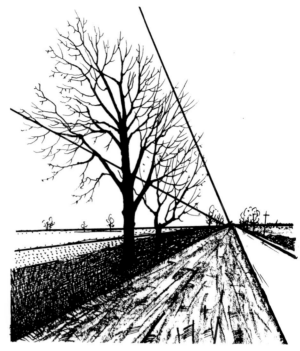

65 *Composition sketch*

converging lines of perspective form an area of interest which opposes the open area to the left. Similarly, the mass of foreground verge and grasses could be treated in contrasting tone and detail to the empty sky above, again offsetting the balance.

It is a good idea to make some composition sketches, similar to the one illustrated in *figure 65*, to explore various alternatives. Note that in this sketch the view has been contracted to lessen the strong pull of perspective, to give a disproportionate division between land and sky areas and to place the large tree slightly off centre. When making decisions about the final design other factors play their part. Consider how each element of the design is to be interpreted technically. With any subject matter devote some time to preliminary planning of this sort.

Suitability of media and supports

The previous two sections of this book have shown that artists have an extensive range of techniques, media and drawing implements available to them. There may be particular characteristics, effects or textures which must be conveyed in the drawing. Such qualities will demand certain techniques which consequently require specific media or drawing tools. In addition, the media or effects may be possible only on a particular kind of paper or support. Initial thinking must therefore consider the choice of media and how these will respond to the type of paper selected. Where possible throughout this book mention is made of the suitability of different media and papers. The section on *Materials and Equipment* gives a substantial amount of information in this respect. Like so many aspects of this subject, good judgement will rely to a large extent upon experience.

Figures 66 to *68* indicate some of the consequences of different combinations. It is always wise to check the response and capabilities of a medium by making some simple

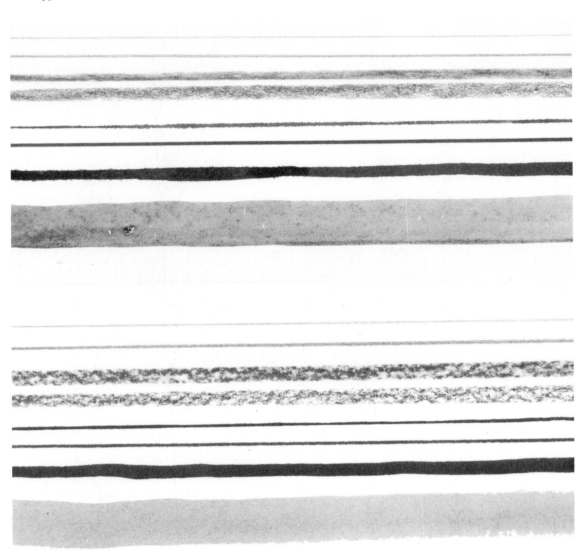

66 *Testing the response of different media to two types of paper*

tests on a small piece of paper of the same type to be used. This is illustrated in *figure 66*. Lines in hard pencil, soft pencil, charcoal, Conté, pen and ink, felt–pen, brush and ink and brush wash have been repeated, first on thin, smooth card in the upper part of the illustration, then on heavy quality paper. Notice how these lines are influenced by the two different surfaces. The charcoal line, for example, is even in application on the card but broken by the heavy texture of the paper; the ink blurs on the card but is readily absorbed by the paper. The reaction between paper and media can cause the sort of contrasting results illustrated in *figures 67* and *68*. These show an attempt to draw the same group of objects in a similar way using charcoal pencil and charcoal. The smooth cartridge paper in *figure 67* invites scope for far greater precision and tonal variations than is possible on the watercolour paper used in *figure 68*.

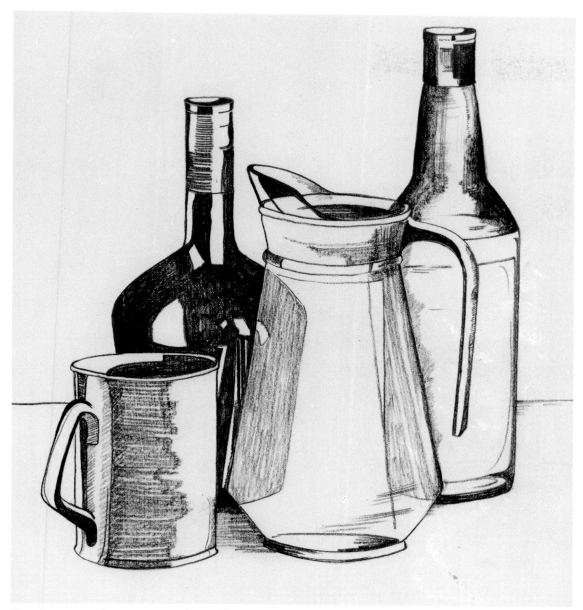

67 *Charcoal pencil drawing,* smooth cartridge paper

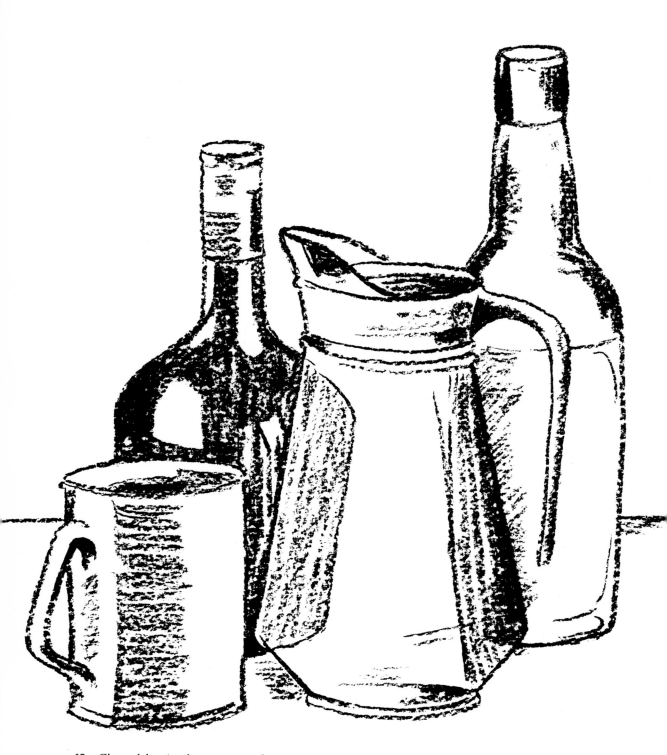

68 *Charcoal drawing*, heavy watercolour paper

Use of sketch book

The sketch book is an essential item of equipment which has various uses. Careful studies made in the sketch book can provide additional reference material when working on a large drawing or painting. Sketches might be done with the aim of gaining a better understanding of the subject matter before working on the final drawing. It can be helpful, for example, to make a series of drawings, perhaps from different viewpoints, to discover and solve any likely problems. The sketch book can be used for preliminary sketches and composition designs as well as for noting down information either in drawn or written form when travelling around. Whether for reference, inspiration or experiment, a good sketch book will be a rich bank of visual material. See *figure 69*.

Advice on the selection of different sketch books is given in the section on *Materials and Equipment*, see page 16.

Use of photographs

Photographs should be used with discretion. Whilst they can be an excellent source of information, equally they can become an inhibiting influence on the work. Do not be tempted to rely on photographs but rather to extract from them what information is required. Photographs are useful when making a strictly representational drawing of something, for they can supply plenty of factual detail. Photography is an ideal way of capturing fleeting moments of action or places and events which cannot be re-visited. However, photographs cannot evoke the sense of occasion or atmosphere and it is always worthwhile making supporting notes or brief sketches to stimulate the memory. Even when working directly from a photograph, as in *figure 71*, the artist may enjoy some freedom and impose some personal interpretation on what he sees.

Perspective and proportion

Perspective is a term which many people misunderstand and overrate. Perspective systems are not the only ways of creating the illusion of depth or the third dimension. Artists such as the Fauves and many abstract painters use entirely different means to achieve independent pictorial space. It was the great men of the Florentine Renaissance who perfected various mathematical principles of perspective and who adopted these with cold calculation in much of their work.

An artist must be aware of various devices for suggesting depth and space in his work and must obviously understand the reasoning which accompanies perspective. However, a drawing which relies totally on perspective will look false and contrived and lack feeling and character. Some subjects will demand a more conscious influence of perspective than others, a view down a street for example, or a still-life. In others the sense of space might be conveyed by contrasts of light and dark or changes of scale and proportion. A landscape drawing might contain no obvious use of lines of perspective but rather rely on reference points within it to indicate relative depth. Changes of scale applied to things which are known to be of a similar size is one way of doing this. A tree in the foreground will thus appear much larger than a tree of equal size in the distance.

For centuries artists have struggled with the problem of creating the illusion of spacial recession on the two-dimensional picture surface. Perspective is a system for achieving this. To explain the technicalities of the system requires far more space than it is possible to devote to them here. The list of *Further reading* on page 116 details several books dealing more specifically with this topic for the reader wishing to make further research into the theories involved. However, in many drawings one has to bear in mind several influential points concerning perspective. An assumption of all perspective systems is that parallel lines receding in a given direction do not remain at a fixed distance from each other but, to give the illusion of recession, gradually converge towards a vanishing point. For example, the sides of a house set at an angle to the viewer would need to be based on parallel lines of this type. Seldom is

69 *Page from a sketch book*

70 *Location photograph*

71 *Drawing from photograph*
pencil, charcoal pencil
and charcoal

the vanishing point included in the drawing, for this produces an exaggerated or unreal quality. Usually the vanishing point is outside the picture area. In pictorial perspective the viewpoint is taken as being the eye level, therefore approximately six feet up from what is known as the ground line, which is the base of the picture. Each set of parallels meets at a separate vanishing point on the line of eye level or the horizon. The point on the horizon immediately opposite the eye is known as the centre of vision. This need not correspond to the centre of the picture, as the artist may take a view from one side. All vertical lines in the picture remain vertical and all lines parallel to the base, remain parallel to it.

Only the very simplest construction will be based on a single vanishing point, other drawings may need two, three or even more vanishing points to achieve greater accuracy or naturalism. A view of a street with buildings set at different angles may need two points for each building. Examples using one, two and three vanishing points are shown in *figures 72, 73* and *74*. *Figure 74* would relate to something like a tall building which recedes upwards as well as from front to back. In these examples the term vanishing point is abbreviated to VP and centre of vision to CV. A preliminary perspective sketch like the one illustrated in *figure 75* is often helpful to establish the main construction lines of a drawing. See also *figures 64, 65, 76, 84* and *85*.

Enlargement and reduction

It is sometimes necessary to make copies of a drawing or to work up a sketch or preliminary study into something larger and more involved.

Duplicates of a drawing are useful for experimenting with technique, colour washes, composition details and so on. Copies can be made directly on to a thin, semi-transparent paper such as detail paper or layout paper, or by taking a tracing. Affix tracing paper with *Blu-tack* or a similar means which will not damage the drawing.

Before making an enlargement, ensure that the large sheet of drawing paper is in proportion

72 *One-point perspective*

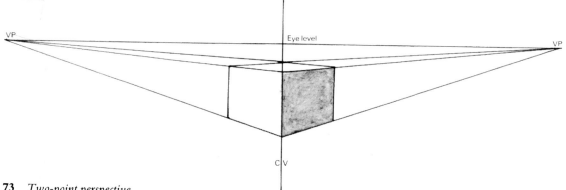

73 *Two-point perspective*

74 *Three-point perspective*

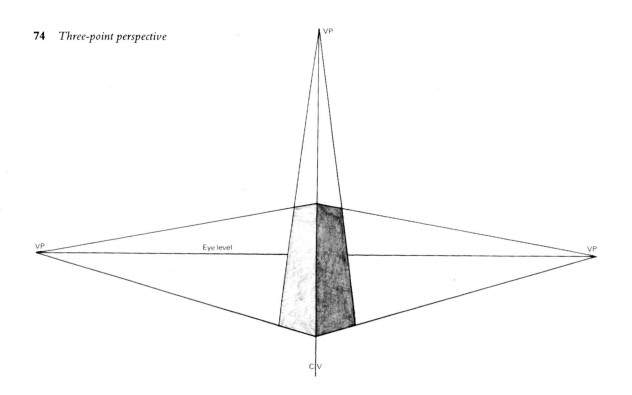

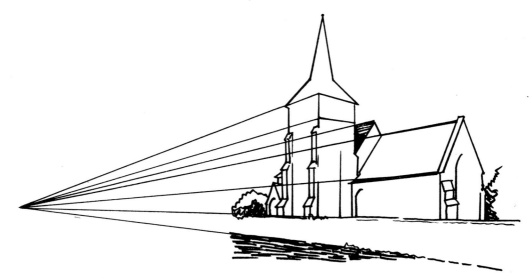

75 *Location sketch to show lines of perspective*

to the original. A quick means of checking this is to place the sketch on the larger sheet so that the top-left corners as well as the top and left-hand edges exactly correspond to each other. Extend the top-left to bottom-right diagonal of the sketch. Any larger rectangle constructed with its bottom-right corner on this diagonal will be in proportion to the original, see *figure 77*. Enlargements can be made by using an episcope or similar machine to project and magnify the drawing, a pantograph, or simply by squaring-up. A squared-up drawing, such as that illustrated in *figure 78*, can be enlarged or reduced on to a support of the same proportions and having the same number of squares along each edge. Work systematically from the top re-drawing the part of the drawing in a particular square in the corresponding square of the copy. Cover the original with tracing paper first if you do not wish to damage it. Use a soft pencil and rule the lines faintly so that they are easily removed later. The image can be distorted by transferring it from a squared-up original to a rectangular division, as illustrated in *figure 79*.

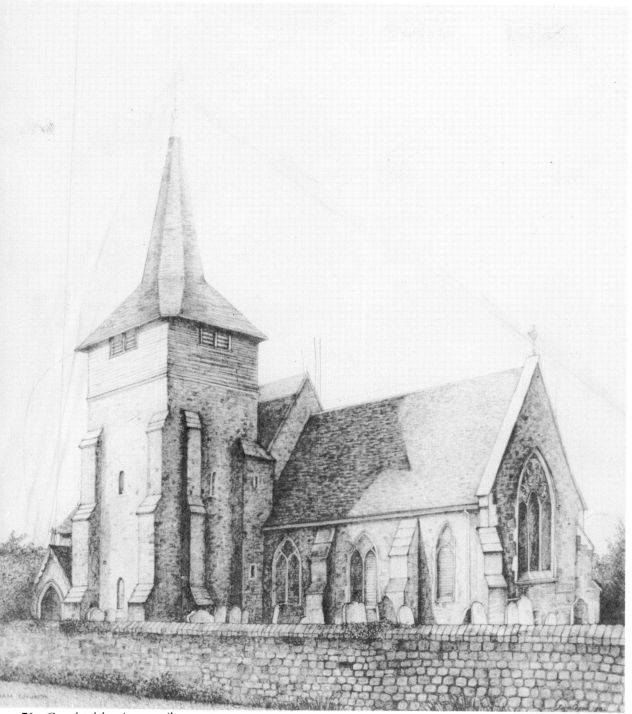

76 *Completed drawing*, pencil

77 *Proportional enlargement*

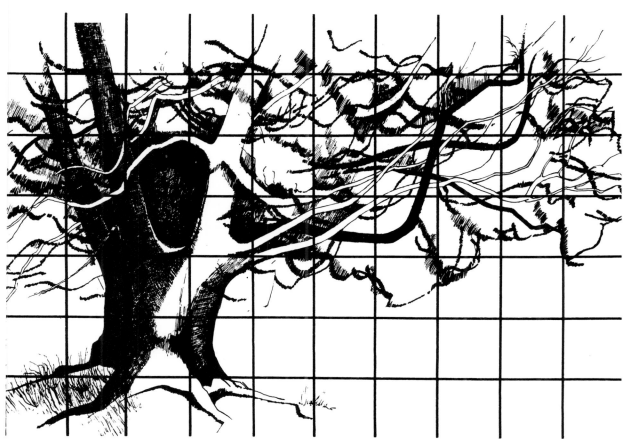

78 *Squaring-up*

79 *Distortion*

Subject Matter

The selection of subject matter is a personal matter. Whilst one artist will be struck by the beauty of a landscape, another will be challenged by the problems of a formal still-life. Whatever the subject, its choice is obviously important in relation to the overall success or failure of the drawing. Inspiration is lost if material resources and technical competence are unable to match it. Equally, a subject may present such a wealth of visual information that it will create confusion to all but the most experienced draughtsman. We are tempted to rely on techniques, media and themes which we know will succeed. Although a drawing is founded on experience it is not likely to be entirely satisfactory unless it demands something more of the artist. Each drawing should contribute to the artist's development. This is not just the physical skill of handling materials, but the visual and mental processes involved in seeing and interpreting. In facing a subject one must be aware of these factors, just as one considers the affinity necessary between means and subject and the suitability of the medium to be used. Earlier sections of this book provide information on the characteristics of media and the suitability of media and supports.

Successful drawing is not necessarily concomitant with an extensive range of subject matter. It is true that to labour always at the same theme may result in weak and tired drawings. However, a study of the work of many distinguished artists will show that a particular theme can provide a constant source of inspiration. Look at the work of Cézanne, for example, and the many studies, watercolours and oil paintings of the 'Montagne Sainte-Victoire'. Monet, Toulouse-Lautrec and Degas are other artists who returned frequently to a favourite theme. To some artists a single theme can hold an inexhaustible mine of ideas and interpretations. A repeat though will be just that unless each renewed aquaintance brings fresh vision and feeling.

In the concluding section of this book brief advice and information is given on some of the most important areas of subject matter for observed drawing. Many of the great innovators in the history of art received a formal training in drawing which was based on the antique or traditional techniques and philosophies. I subscribe to the belief that an individual vision and style can only be attained after the assimilation of information concerning the basic equipment and techniques with which the artist works and a knowledge and experience of traditional means and subject matter. Partly for this reason, and partly because of limited space, there is no mention here of abstract, imaginative or the highly personal work which may evolve from this.

Natural forms

Nature offers a wealth of exciting subjects for drawing. Indeed, for the beginner this is a good area to explore because of the variety of forms and the fact that many of them are easily obtained and transported back to the studio. Take advantage of trips to the beach and country walks to build up a collection of natural forms. Scouring the beach might reveal interesting shells, marine life, pebbles or pieces of driftwood. In the countryside, bark, feathers, animal bones, stones and flints will be found in addition to the immense range of leaves, grasses, plants and flowers. After cleaning, some of these items will keep indefinitely. Others may need drawing immediately before they wilt or decay.

The characteristics of the selected form will necessitate a particular approach. Whilst one may return again and again to draw a permanent object such as a bone or flint, the transient character of many wild flowers, even when drawn *in situ*, demands an immediate approach. There are advantages and disadvantages in both. The bone allows us to spend as much time as we wish on it, perhaps on different days or even weeks, so that a very thorough and detailed drawing is possible. It is difficult though to return to a drawing after a lengthy absence and maintain its vigour and one's enthusiasm for it. Contrastingly, one has to work directly and confidently on a flower in full bloom; this may produce a freshness and vitality in the drawing but an unfinished result. When possible, arrange the item in good light, perhaps placing it on a large sheet of white paper to isolate the form

80 *Studies of bones*, pencil

81 *Preliminary sketch with lines of axis and construction* **82** *Studies of hollyhocks*, pencil

clearly. As always, spare some thought for the materials and techniques to be employed. Natural forms are suited to careful, controlled work just as they are to a freer, analytical approach, perhaps from a variety of viewpoints, made in a sketch book.

Figure 80 shows some careful pencil studies of a bone made from different viewpoints. Many natural forms, as in this example, combine various textures and surfaces which prove a good test for the artist. It may be helpful, as in *figure 81*, to begin by suggesting the form with a few construction lines drawn lightly in soft pencil. The form can thereafter be evolved around a 'skeleton' of this type. Flowers and plants are particularly demanding subjects. Look at the two contrasting approaches in *figures 82* and *83*.

Still-life

Here is a theme which has fascinated many artists during the last few hundred years from the Dutch masters, such as Willem Kalf, to modern painters such as William Scott. Despite its contrived, sometimes imposing nature, it is a theme open to many interpretations from formal, representational drawings to the subjective, semi- abstract. Compare the work of Courbet and Braque, for example, or Pierre Roy and Matisse.

The traditional still-life is composed of a group of objects set on a table, usually with a positive light source so that shadows emphasise the forms. The composition is thus contrived by the artist. The objects may be selected because of their affinity within a certain theme, because they exhibit a variety of textures and forms, because of dramatic contrasts between forms, or for less obvious and more subjective reasoning. A group could therefore be based on gardening equipment, home decorating or kitchen utensils just as it could explore the contrasts between cylindrical and cuboid forms. The classic still-life composed of broken bread, wine and fruit remains a challenging mixture of textures and shapes. As with natural forms, it is worth making a collection of interesting items. These can be obtained from a variety of sources, including jumble sales and junk shops.

In arranging the collection of items, take some care to achieve an interesting grouping through the considered juxtapositions of objects as well as lighting effects. Regard spaces as an inherent part of the design. In general, avoid large gaps and isolating objects. To begin with, keep to a small number of common objects. Indeed, the beginner is advised to concentrate on simple, individual forms. The objects will normally be placed in a neutral setting, as against a screen, backcloth or plain wall. The size of the objects and the scale of working will determine the

83 *Blue Chrysanthemum* by Piet Mondrian. Watercolour and ink. *The Solomon R Guggenheim Museum, New York. Photograph by Carmelo Guadagno. Copyright SPADEM 1983*

distance at which the artist works. This will usually be some six to eight feet from the group. Assess the objects from a variety of viewpoints to determine which angle provides the most

interesting aspect. If the group is arranged on a large drawing board covered with a sheet of off-white paper, then the board can be rotated relative to the fixed position of the artist to ascertain the best view. Another advantage of having the objects on a covered board is that their positions can be marked by drawing round their bases. Should one item have to be removed or be knocked over, it can be re-positioned quite accurately.

A faithful interpretation of the forms involved may depend very much on a methodical approach and the careful construction of shapes. Preliminary work should concentrate on mastering the construction of basic forms, as illustrated in *figures 84 to 88*. Perspective views of boxes, whether open or shut, cylinders and symmetrical shapes are all good starting points. Tone, shading techniques and perspective, topics covered in previous sections of this book, will be of importance here. Use whatever construction lines seem necessary to produce an accurate outline. Draw these lines in soft pencil so that they can easily be erased when of no further value. Use a straight-edge if required. Notice from the diagrams how the basic shape is constructed first before handles and other modifications are developed from it. Practise drawing elipses and curves. Turn the paper round as necessary; it is easier to draw a curve from the inside. Do not overlook the proportions of an object; make estimates of its width comparable to its height. A symmetrical object, such as a bottle, can be constructed from a central line, see *figure 88*. When half the shape has been drawn in, take the distance of relevant points from the centre and measure off points in line with those on the opposite side. Use a series of marks obtained in this way to establish the remainder of the shape.

Approach the drawing of a collection of objects in a similar, methodical way. Relate the size of the group to the size of the sheet of drawing paper and determine relative proportions. Estimate where the vertical centre of the group is and match this to a central guide line on the drawing paper. Work from the centre outwards. The positioning and scale of the 'key', central object is of prime importance in constructing a successful drawing. Draw in each shape, first with weak, approximate lines, then with accurate outlines. As before, use whatever construction lines are necessary. Look at the size of the 'negative' spaces as well as those of the 'positive' forms. When all construction problems have been solved and the drawing has reached the finished outline stage, rub out the guidelines and begin work on tone and detail. As a general rule, work from the back to the front of the group. Analyse the lighting carefully and the relative tone of one surface to another. *Figures 89* and *90* illustrate two such drawings.

The careful, controlled approach has much to commend it but now and again it is good to adopt a much freer method. Other techniques and media will encourage this. Chalk and charcoal drawings, for example, are ideal for a bolder approach concentrating on light and dark modelling of form rather than specific detail. Sketches in this manner are also useful as preliminary investigations before attempting a detailed study.

84 *Construction lines: boxes*

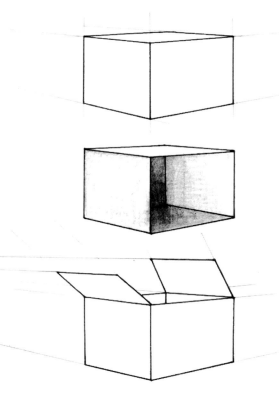

85 *Construction lines: chair*

86 *Construction lines: cylinder*

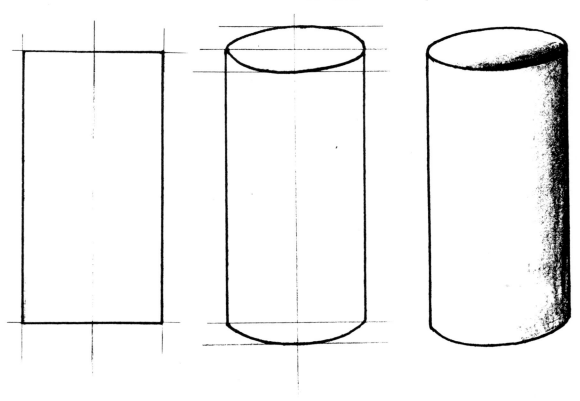

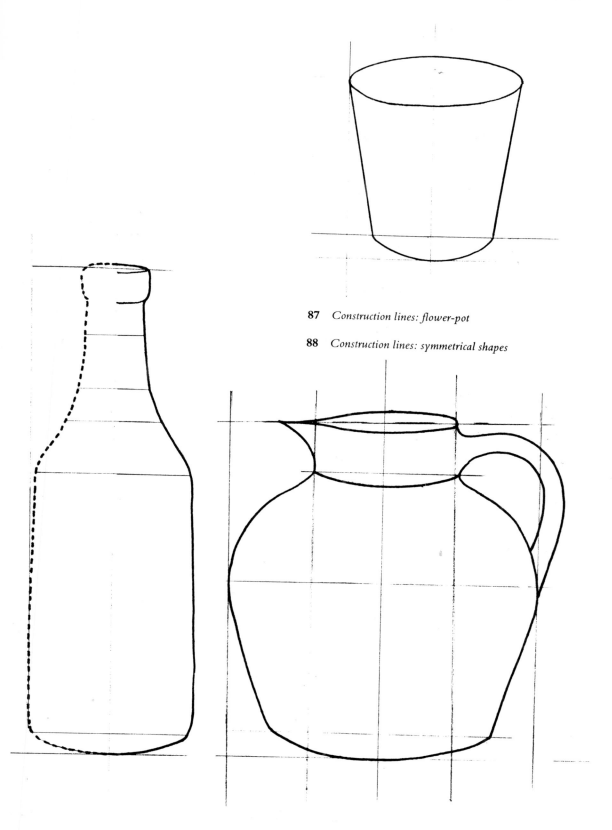

87 *Construction lines: flower-pot*

88 *Construction lines: symmetrical shapes*

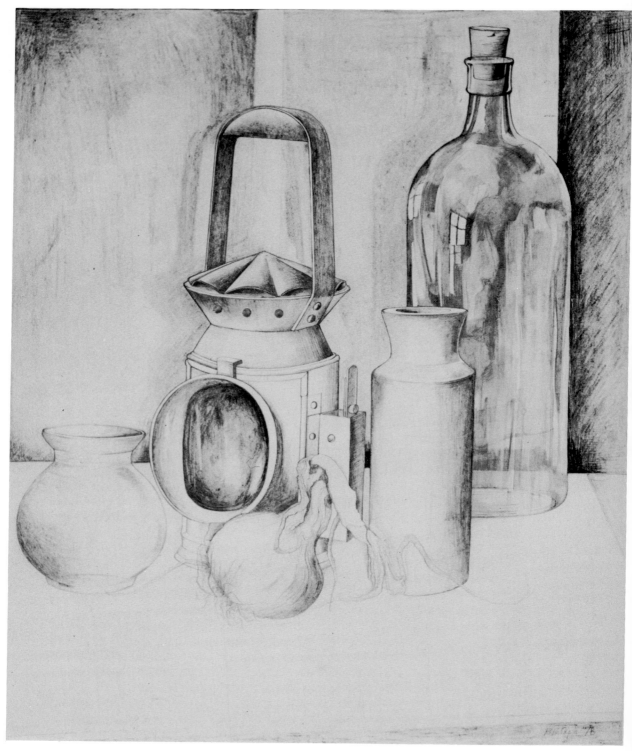

89 *Still life group*, pencil, ink wash, charcoal pencil and charcoal

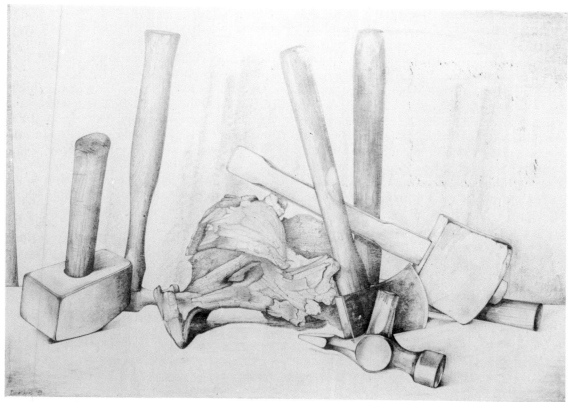

90 *Still life group*, soft pencil and charcoal

Landscape

Landscape can be the most rewarding of subject matter, but notwithstanding, one which can present the unwary with immense problems. We are fortunate in this country to enjoy a landscape of such variety. Whether we like the sweeping aspect of moorland, an intimate corner of a Kentish orchard, fields of waving corn or a choppy estuary, we have plenty to inspire us. Many great artists have found this so: Turner, Constable, Cotman, Girtin and Samuel Palmer amongst them.

Landscape drawings cannot be produced successfully indoors so one must get out on location. A drawing similar to the one illustrated in *figure 92* can be made in the warmth of the studio providing there is sufficient first-hand knowledge, sketches and other information to work from. Photographs can also be useful, but

again, must be supported by personal experience of the subject. Sketch book work, written notes, colour sketches, composition roughs are all recommended, in addition to location work in a quick-response medium such as charcoal, colour wash or pastels. The weight and bulk of essential equipment for attempting such work outside should be kept to a minimum. Sketch books should be of the type which has a firm, cardboard backing sheet to give support. Large drawing boards can be heavy to carry any distance, thus a small sheet of plywood or even hardboard can be preferable. It is not always easy to find a comfortable vantage point from which to draw, so a light-weight folding stool can be useful. Folding easels are not very stable and are generally unsuitable for drawing. Be prepared for the fickle nature of weather by having waterproof protection for sketch pads, paper and boards, as well as yourself!

Problems of comfort and working conditions apart, changeable lighting and sometimes the

panoramic scope of the subject can cause confusion. It takes a trained eye to assimilate a complex view and reduce it to pictorial coherence. As a rule, the beginner is advised to select a view in which broad areas of landscape are contrasted with something of more detail in the foreground. References, such as figures, animals, trees and houses, are useful to establish relative scale and distance. Alternatively, tackle a 'ready-made' composition, for example a view between two trees or that framed by an arch or under a bridge. Devices may be necessary to isolate a particular area for attention. If you hold up your hands in front of your face, irrelevant parts can be blocked out, so concentrating the vision on a given area. A square hole cut from a small sheet of cardboard will serve the same

purpose. Half close the eyes occasionally to eliminate detail and see the main elements of the composition. In contrast, a broad, simple landscape view can lull the artist into slick lines and unsympathetic forms. The distribution of light and dark is of great importance; weak distant areas may be set against bolder, more detailed foreground shapes. The sky can play a vital part in unifying the composition and adding to the sense of space and distance.

As in *figure 91*, the landscape drawings of Van Gogh show a highly personal response to the subject with lines of great vigour and feeling. *Figure 92* is a large, studio drawing made from information collected from location visits. In *figure 93* the sweep of distant landscape is contrasted with the bold tree forms of the foreground, whilst similarly in *figure 94*, strong lines lead the eye into the composition.

91 *Cornfield with Cypresses* by Vincent Van Gogh.
Reed pen and pencil
Stedelijk Museum, Amsterdam

92 *The River Medway at Yalding, Kent*, pencil

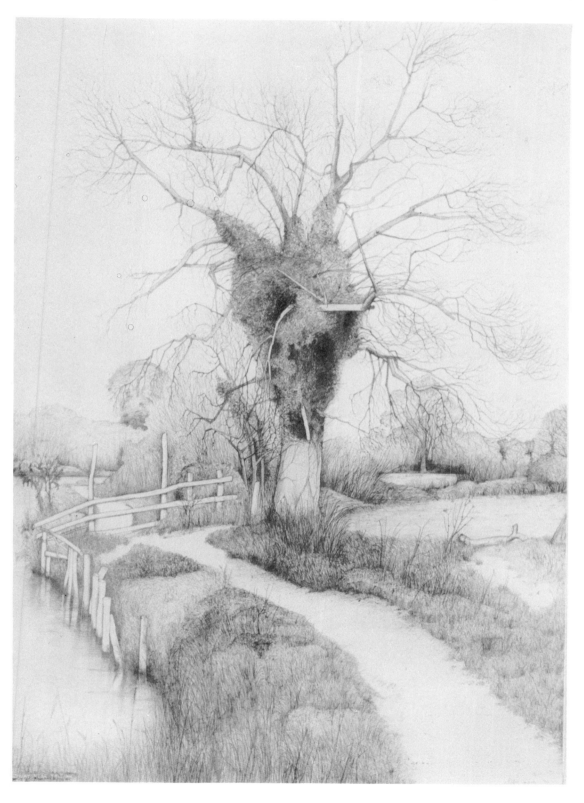

93 *Landscape view near Wollaston, Northamptonshire,*
pencil and charcoal

94 *The River Nene at Earls Barton, Northamptonshire,*
pencil and charcoal

Life

Possibly because it is difficult to treat it completely objectively, the human form is one of the most challenging things to draw. Naturally, from earliest times, there is a wealth of pictorial evidence to study. Whether for nude drawings, posed or character studies, or quick figure sketches, look at the work of some well known artists to see how they have solved the problems of pose, proportion and form. There is much documentation and many drawings, illustrations and woodcuts by some of the early masters based on the study of the human form and its proportions. For example, in the last year of his life, Albrecht Dürer compiled an extensively illustrated book for art students entitled *Vier Bücher von Menschlicher Proportion*, Four Books on the Human Proportions. Vitruvius stated that 'the measurements of men are arranged by Nature thus The span of a man's outstretched arms is equal to his height'. Such facts are graphically illustrated in the notebooks and studies of Leonardo da Vinci.

As with most drawing, an understanding of the underlying structure of the subject is helpful. Familiarisation with the basic anatomical details and proportions of the human form makes a sound starting point. Do some research and make some notes and sketches. Persuade someone to pose for you so that your can make your own investigations into proportion. Begin with the standing figure and simple line drawings which analyse basic forms and the relative sizes of different parts of the body. Look at the size of the head in relation to the rest of the body and the length of the limbs. Pay particular attention to the size of hands and feet, which are frequently drawn too small. Be prepared to make alterations and repeat the process as many times as is necessary to develop a confidence in figure sketching. Progress to modify the pose into various positions. Look for helpful lines of construction, like the curve of the spine. Drawings can be done in charcoal or pastel so that tone can be introduced to model the forms.

Just as some study of anatomy can aid the understanding of form it may follow that the drawing of the nude figure should precede

95 *Study of a Nude* by Michelangelo. Black chalk *Teylers Museum, Haalem*

draped or clothed studies, for it helps in drawing the clothed figure if one appreciates the form beneath. The opportunity to draw and paint the nude is not necessarily limited to practising artists. Many local authorities run excellent evening classes in life drawing; these also provide the opportunity to meet other students as well as receive advice and guidance from professional teachers. Here again, it is profitable to start with short, linear sketches, as illustrated in *figure 96*.

Whether nude or clothed, the pose of the model needs careful consideration. Often a compromise is necessary between what can be comfortably maintained by the model and what seems interesting to draw. The model will need

96 *Quick sketches of a nude*, pencil

97 *Lines of construction: life drawing*

rests, so if possible devise a means of marking the position of the body against a backing or ground-sheet. Mark round the position of the feet of a standing model. Give some thought to the lighting and plan out the size of the composition and the medium to be used. Evolve the drawing around helpful lines of construction, constantly checking the size and position of one part in relation to others. See *figure 97*. Notice how light and dark affects the form and use this to advantage.

In addition, use a sketch book to jot down quick character studies and figures in action. Develop some of these sketches later in the studio, possibly with reference to a posed model, or even photographs.

98 *Life drawing*

99 *Study of the Transfiguration* by Raphael. Pencil *Ashmolean Museum, Oxford*

Portrait

Many of the points just discussed will relate equally to the drawing of portraits. Although every face is individual, certain facts relating to structure and proportion remain similar. A useful way to start is to make some sketches in the manner of *figure 100*. Notice how all the features of the face are confined to the lower half, so that a line drawn horizontally through the eyes divides the head approximately in half. Examine the spacing and position of the other features. The space between the eyes, for example, is generally equivalent to the length of one eye. Check the length of the nose in relation to the position of the ears and the overall length of the face in comparison to its width. Practise

drawing some theoretical faces in this way before progressing to the real thing. Remember that such faces are idealistic and modifications may have to be made when drawing from life. On a model, to begin with, repeat this analysis of proportion and structure. Apply the same process to the head posed in different positions: profile, three-quarter view, tilted forward, leaning to the side, and so on.

Soft pencil is a good medium to start with, though portrait drawings can be successful in a wide range of media, including charcoal, Conté, pastels and chalks. Often it is wise to combine media; charcoal is good for soft tones whilst more precise detail is drawn in pencil.

In the absence of a model, good black and white photographs are useful to work from. These will readily show highlights and areas of varying tone and therefore leave the artist to concentrate on form and likeness. Look in magazines for large photographs of interesting faces. Drawings can also be made from squared-up photographs. However, be wary of such methods: there is no real substitute for a life model.

It will take a good deal of experience and practice to capture a likeness and a greater insight to give the drawing character.

There are many occasions in this book where the reader is urged to look at the work of other artists for both educational and inspirational reasons. Portrait drawing is no exception to this. It is interesting to explore the immense variety of approaches adopted by artists over the centuries. Compare, for example, the portraits of Modigliani with those of Dürer, and the economy of a Matisse with the intensity of a Rembrandt. The concluding four illustrations are more than examples of good portrait drawings for they demonstrate the versatility and power of the art of drawing.

100 Head: basic proportions and construction lines

101 *Woman with the Crazy Eyes* by Augustus John.
Hard black pencil on white paper, 22 cm × 17.7 cm
Isabella Stewart Gardner Museum, Boston,
Massachusetts

102 *Self-Portrait* by Stanley Spencer. Pencil on
white paper. 35.5 cm × 25.4 cm
Victoria and Albert Museum, London

103 *Portrait of Isabella Brant* by Peter Paul Rubens. Black, red and white chalk with light washes on light brown paper, 38 cm × 29.5 cm.

Eyes strengthened with pen and black ink
British Museum, London

104 *Dame Edith Sitwell* by Wyndham Lewis
National Portrait Gallery, London

Further Reading

Drawing: Seeing and Observation, Ian Simpson, Van Nostrand Reinhold Company 1973

Seeing Through Drawing, Philip Rawson, BBC 1976

The Craft of Old-Master Drawings, James Watrous, The University of Wisconsin Press 1975

Drawing Ideas of the Masters, Frederick Malins, Phaidon Press 1981

History of an Art of Drawing, Jean Leymarie, Genevieve Monnier and Bernice Rose, MacMillan 1979

Encyclopaedia of Drawing, Clive Ashwin, Batsford 1982

Pencil Sketching, Thomas Wang, Van Nostrand Reinhold Company 1977

Drawing with Pencils, Norman Laliberté and Alex Mogelon, Van Nostrand Reinhold Company

Rendering in Pencil, Arthur L Guptill, Watson-Guptill Publications, New York 1977

Charcoal Drawing, Henry C Pitz, Watson-Guptill Publication, New York 1981

Drawing with Ink, History and Modern Techniques, Norman Laliberté and Alex Mogelon, Van Nostrand Reinhold Company

Drawing with Markers, Richard Welling, Pitman Publishing London and Watson-Guptill Publications, New York 1974

Approaches to Crayons, Chalks and Pastels, Guy Scott, Evans Brothers Limited

Using Pastels, Joan Scott, Frederick Warne Ltd, 1981

Pastel Painting Workshop, Albert Handell and Leslie Trainor, Watson-Guptill Publications, New York 1981

How to Paint Figures in Pastel, Joe Singer, Watson-Guptill Publications, New York and Pitman Publishing, London 1976

Pastel Painting Techniques, Guy Roddon, Batsford 1979

Pastel, Charcoal and Chalk Drawing, Norman Laliberté, Alex Mogelon and Beatrice Thompson, Van Nostrand Reinhold Company

Techniques of Drawing, Fred Gettings, Orbis Publishing 1981

The Natural Way to Draw, Kimon Nicolaîdes, André Deutsch Limited 1972

Principles of Perspective, Nigel V Walters and John Bromham, The Architectural Press 1970

Drawing Perspective, Hugh Chevins, Studio Vista Limited 1966

Perspective: A Guide for Artists, Architects and Designers, Gwen White, Batsford, new edition 1982

How to Compose Pictures, J M Parramón, Fountain Press 1973

Design Lessons from Nature, Benjamin Debri Taylor, Watson-Guptill Publications, New York 1974

Landscape Drawing, John O'Connor, Batsford 1977

Anatomy and Figure Drawing, Louise Gordon, Batsford 1979

Portrait Drawing Techniques, Diane Flynn, Batsford 1979

Mounting and Framing Pictures, Michael Woods, Batsford paperback 1982

Suppliers

Most basic drawing equipment is obtainable from local art shops and stationers. It is preferable to visit a good art and craft supplier in order to see and handle materials before purchase. Catalogues from the general suppliers below will show a good range of equipment but mail order can incur postage and handling charges.

Great Britain

Fred Aldous, 37 Lever Street
 Manchester M60 1UX
Art and Crafts, 10 Byram Street
 Huddersfield HD1 1DA
L Cornelissen and Son, 22 Great Queen Street
 London WC2
Crafts Unlimited, 178 Kensington High Street
 London W8; 11 Precinct Centre, Oxford
 Road, Manchester 13; 202 Bath Street
 Glasgow C2 and 88 Bellgrove Road, Welling
 Kent
Dryad Limited, Northgates
 Leicester LE1 4QR
Lechertier Barbe Limited, 95 Jermyn Street
 London SW1
Clifford Milburn Limited, 54 Fleet Street
 London EC4
Roberson and Co Limited, 71 Parkway
 London NW1
Reeves and Sons Limited, Lincoln Road
 Enfield, Middlesex
George Rowney and Co Limited
 10 Percy Street
 London W1
Winsor and Newton Limited,
 51 Rathbone Place
 London W1 and branches

Papers
Falkiner Fine Papers Limited, 4 Mart Street
 off Floral Street, Covent Garden
 London WC2E 8DE
F G Kettle, 127 High Holborn
 London WC1
Grosvenor Chater and Company Limited
 68 Cannon Street, London EC4
T N Lawrence, Bleeding Heart Yard
 Greville Street, London EC1
Paperchase, 216 Tottenham Court Road
 London W7
Spicer Cowan Limited, 19 New Bridge Street
 London EC4
Strong Hanbury Company Limited, Peterborough
 Road, Fulham, London SW7
Paper offcuts may also be obtainable from local printers.

USA

Arthur Brown and Bro Inc, 2 West 46 Street
 New York
A I Friedman Inc, 25 West 45 Street, New York
Grumbacher, 460 West 34 Street, New York
The Morilla Company Inc, 43 21st Street,
 Long Island City, New York and 2866 West
 7 Street, Los Angeles, California.
*New Masters Art Division: California Products
 Corporation,* 169 Waverley Street,
 Cambridge, Massachusetts
Stafford-Reeves Inc, 626 Greenwich Street
 New York NY 10014
Steig Products, PO Box 19, Lakewood
 New Jersey 08701
Winsor and Newton Inc, 555 Winsor Drive
 Secaucus, New Jersey 07094

Papers
Chicago Cardboard Co, 1240 N. Homan
 Avenue, Chicago 51
Hobart Paper Co, 11 West Washington Street
 Chicago, Illinois 60600
Japan Paper Co, 100 East 31st Street
 New York 16
Wellman Paper Co, 308 West Broadway
 New York, NY 10012
Andrew/Nelson/Whitehead Paper Corporation,
 7 Laight Street, New York 13
Yasutomo and Company, 24 California Street,
 San Fransisco, California 94111

Index

Numerals in *italics* refer to figure numbers